Saints

Congratulations to
a hero, and Saint
to me… or softly
others…
Welcome to our
faith, Shawn

Brian Bath
Nov 30, 2013

JACQUES DUQUESNE

Saints

Men and Women of Exceptional Faith

Flammarion

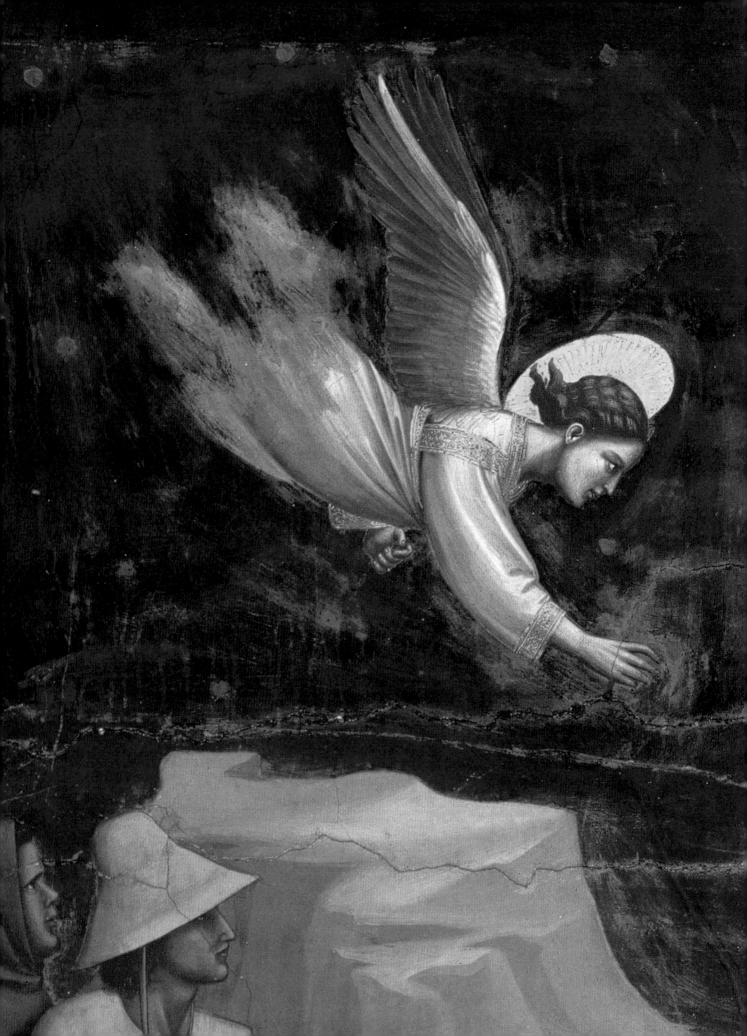

CONTENTS

Saints

Saints are everywhere. They affect the daily lives of millions of people and have lent their names to countries, islands, mountain ranges, cities, streets, squares, works of art, and individuals, as well as train stations, public buildings, and stadiums. Some, like Valentine (a third-century bishop who became the patron saint of lovers), or Nicholas (another bishop in the fourth century who prefigures Father Christmas) have reaped massive profits for businesses. Saints are also found in churches and chapels. And even if attendance at services has dropped around the world, saints still draw increasing crowds to Santiago de Compostela, Lisieux, Lourdes, Fatima, and Rome, but also to less well-known sites, like Ostrog in Montenegro, Almonte in Spain, and Aparecida in Brazil.

Today there are also spontaneous canonizations that are not recognized by the Church, which has for centuries dictated specific rules for recognizing who is a saint or on the way to becoming one. Mother Teresa, an Albanian woman who for forty years devoted her life to the poor and sickly children of Calcutta before expanding her activities to the whole world (which earned her the Nobel Peace Prize) is an example of one such decision. Pope John Paul II finally beatified

Giotto di Bondone,
Moses,
c. 1303–05.
Scrovegni Chapel, Padua.

her in Rome in October 2003, but the people of the world had already made her a saint "by unanimous vote." The final decision is still not official.

In a different way, this is also the case of the American Baptist minister, Martin Luther King, Jr., whose writings and speeches are often read not only at the services of his church, but also during the mass at Catholic churches in the United States. King, who also received the Nobel Peace Prize, was assassinated in Memphis, Tennessee. Although Protestantism is a little ungenerous when it comes to recognizing saints, the Baptist church in Montgomery, where King was pastor, displays a mural representing Martin Luther King, Jr. in a long white tunic, floating in an aura of light after his death. This image is similar to that of many saints.

Popular worship attributes a human yet spiritual quality to such individuals that brings them closer to God, even if theology and official guidelines, which move at a slower pace, do not yet recognize these persons as saints per se.

"God alone is holy," according to the Hebrew Bible. For thousands of years, Jews have believed in one God. By the same token, do they believe in only one saint? This is true at least for the earliest authors of the Bible. For them and their followers, sanctity was the very nature of the divinity and belonged exclusively to God. He alone was "pure," and everything else was "impure," except what was related only to Him. So the center of the temple in Jerusalem (where God was at once present and absent, since He could not be enclosed in a stone building), which only the high priest was allowed to enter, was called the "Holy of Holies." And the land where the Jewish people lived, "Eretz Israel," was "the Holy Land."

When we say that God is a saint, we are insisting not only that He has never done wrong (unlike the gods who dwell on Mount Olympus), but also that he is not stained by any impurity. Such statements affirm that He does not resemble in any way what we can humanly know or imagine.

But in Leviticus, one of the most difficult books in the Bible to interpret (although it is fundamental to an understanding of divine saintliness), God's love for us confers "his laws and customs" on mankind, which means everything that we should and should not do to come closer to Him. This is why five great figures are exceptionally privileged to qualify as "saints" in the Hebrew Bible: Moses, Samuel, David, Elijah, and Elisha, who were all prophets. But it is somewhat surprising to note that in this period, the special title of saint was also attributed to King David, who not only had adulterous relations with Bathsheba but also had her husband, Uri, put to death.

It is true, however, that this complex character did finally succeed in having the Ark of the Covenant, a sacred symbol of God's covenant with the Jews, brought into Jerusalem.

The religious criteria for sainthood were evolving. As imperfect as these five men might have been, they were chosen by God to appear on earth in His place, to convey His wishes to His chosen people, and to perform special miracles as signs of His greatness and love, or ultimately to perform an extraordinary act that would allow the Jewish people to approach the "Holy of Holies." Allowing the Ark of the Covenant to enter Jerusalem would of course qualify as such a feat.

The inhabitants of the Mediterranean world were not really so different from each other. Ideas and beliefs circulated from one land to another, even if religious leaders were wary of any outside contamination. So it was that the Greeks, for whom saintliness was also the privilege of a single divinity, could also make exceptions. In the Greek tradition, heroes who excelled in strength and deeds might also gain admittance to the home of the divinities on Olympus, and reach a state of perfection. Regardless of whatever else he did, David could be considered a hero, and a saint, although a distinction must be made between the two.

But in terms of saintliness, the real revolution came with the birth of Jesus, for the not so simple reason that he was God and man, mortal and immortal,

Anonymous,
The Ascension of Elijah,
seventeenth century.
Villa Doria Pamphili, Rome.

a tortured victim and a conquering hero. For his contemporaries, as well as for many men and women for centuries thereafter, the dogma of his incarnation, the deeply fundamental uniqueness of Christianity, was quite difficult to accept.

If mankind is expected to imitate Jesus Christ who is God, then men and women may also share in God's saintliness. In fact, they may, but above all they *must* be saints—all of them, not only a few prophets chosen by God to serve as His intermediaries.

For Christianity, this signifies the end of the belief that "God alone is holy." Anyone can approach saintliness, although in Leviticus we find God's injunction: "Be holy as I am holy" (Leviticus 19:2). But the context shows that the authors of this phrase did not mean to encourage us to become a different godlike figure, since faith in one God was Israel's most original feature in the known world of the time. When we read the prophets, we must interpret the moral and spiritual meaning of this text in a way that does not change the nature of mankind. In the New Testament, there is a universal call to saintliness. When Jesus says that He is the Way, he is emphasizing that whoever follows Him, understands His counsel, and applies His commandments is on the road to the saintliness of God.

Of course the notion of sanctity has somewhat faded over the centuries; it often has connotations of a higher moral standard and an intense spiritual life that is rarified and exemplary. But we are reminded of the core of the Christian message in Peter's first letter: "but like the Holy One who called you, be holy yourselves also in all your behavior; because it is written, 'You shall be holy, for I am holy.'" (1 Peter 1:15–16) The Apostle Paul says the same in his first letter to the Corinthians, where he insists that they are "saints by calling, with all who in every place call on the name of our Lord Jesus Christ" (1 Corinthians 1:2).

This was a real revolution. In antiquity, a moat—or rather an insurmountable ravine—separated mankind and the gods. Christ built a bridge or viaduct as a broad pathway linking the two sides of the gap between earth and God. It is easy to accept that, even today, this connection is fairly incomprehensible: how are we to grasp the meaning of the orthodox theologian Olivier Clément's statement that "saintliness is life that has finally been freed from the snares of death?"[1]

1. Quoted by Anne-Marie Pelletier, "La sainteté … autrement" (Saintliness … otherwise), in *Des saints, des justes*, ed. Henriette Levillain (Paris: Autrement, 2000).

Philippe de Champaigne,
The Dream of Elijah,
1656.
Musée de Tessé, Le Mans.

It appears, however, that the first Christians did not hesitate to call themselves "saints" among themselves. When the apostle Paul, who had become blind for three days, entered Damascus, the Christian Ananias evoked Paul's past life as a persecutor of Jesus's disciples contemptuously, protesting to God, "Lord, I have heard from many about this man, how much harm he did to Your saints at Jerusalem" (Acts of the Apostles 9:13). Fortunately, as we know, God enlightens him and explains that Paul has changed, that He spoke with him on the very road to Damascus. He is sending Paul to Ananias so that he may restore his sight. After becoming an apostle, Paul writes to the Christians of Colossus that they are "saints and faithful brethren in Christ" (Colossians 1:2). Paul also tells the Ephesians that "you are no longer strangers and aliens, but you are fellow citizens with the saints, and are of God's household" (Ephesians 2:19). Finally, we should underline that Mary and the apostles had been considered "saints" since the early days of the Church.

This vision of saintliness is evidently different from the Jewish view. However, their conception of sainthood developed over time, since it was originally attributed only to certain men who acted by God's authority and under his influence. Above all, the call to saintliness that was first addressed only to the tribe of Israel was later extended to all of humanity. Every human being could participate in God's sanctity.

In the history of beliefs, there are of course a few exceptions. Three angels—Gabriel, Michael, and Raphael—are venerated and considered saints. Angels are obviously not humans, but spirits who are close to God and serve Him as messengers. The Hebrew word *malakim*, which was translated into Greek as *angeloi*, and then into Latin as *angeli*, means "envoys" or "messengers." It was in this guise that the well-known figure of Gabriel appeared to the Hebrew priest Zacharias and told him that his wife Elizabeth, Mary's cousin, would have child who would become John the Baptist. But this was only the start, since Gabriel is recognized above all as the angel who announced to Mary of Nazareth that she would be the mother of Jesus Christ.

Giovanni della Chiesa,
The Annunciation to Zacharias,
1493.
Church of Santa Maria Incoronata, Naples.

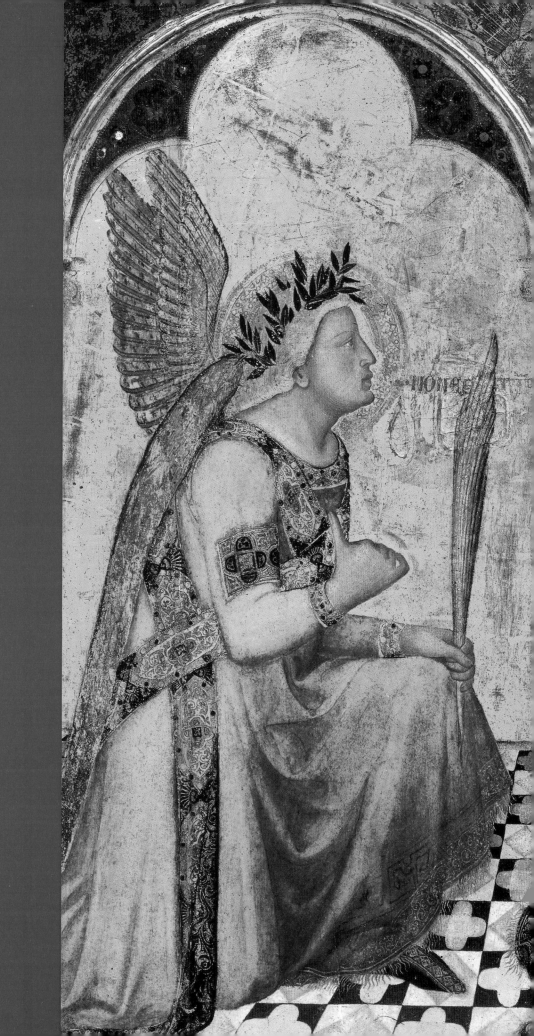

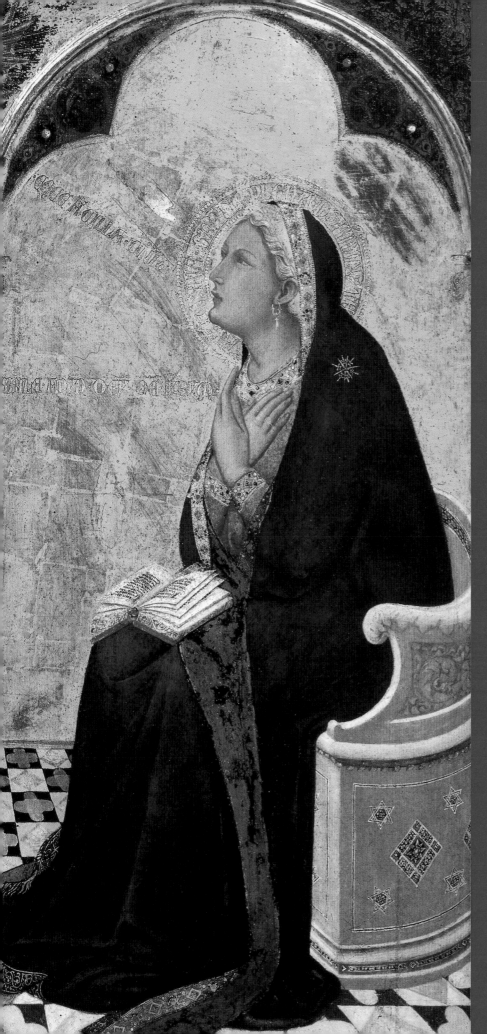

Ambrogio Lorenzetti,
The Annunciation (detail),
1343.
Pinacoteca Nazionale, Siena.

In the Old Testament, Saint Michael appears in the Book of Daniel as the protector of Israel and in Revelation as the leader of the celestial armies that combat the dragon. This explains why painters and popular tradition depict him as a knight in armor bearing a sword. Mont-Tombe in Normandy was scarcely known before the year 1000. But Aubert, the bishop of Avranches and a saint himself, had a church built there after receiving the order from Saint Michael; the Benedictines founded a monastery there in 966, after which the fame of Mont-Tombe, now Mont-Saint-Michel, spread far and wide.

We know less about Saint Raphael. He appears only once in the Book of Tobit in the Catholic and Orthodox biblical canon, when he heals a blind man and an unfortunate woman. Only after performing these miracles does he reveal himself as "one of the seven angels who are always waiting to intervene on behalf of God's glory." In other words, he looked like a man, but because of the angels' role as messengers between heaven and earth, it became customary to represent them with wings, like great birds.

In 745 CE the Lateran Council recognized that these three angels shared in God's sanctity. So there were pre-Christian angels, even if Christianity itself later developed the cult of saints, codifying it and demonstrating its breadth.

As early as the second century, Christian believers venerated martyrs as the broken or bloody witnesses of Christ. In upcoming chapters, we shall see the rapid development of the cult of saints who protected specific places and professions and could cure certain diseases.

The Christian church curtailed the spontaneous attribution of sainthood to individuals who had specific attributes. But in the sixteenth century, the Council of Trent confirmed that the saints who reigned with Christ and offered special prayers to God for the faithful were special intermediaries in their own way.

This was a response to the Protestant Reformation. For most Protestants, Christ was the only worthy intermediary. In fact, they emphasized that the apostle Paul—in his first letter to Timothy (one of the disciples whom he sent to Ephesus

to fight against heresies)—declares that "there is one God, and one mediator also between God and men, the man Christ Jesus" (1 Timothy 2:5). And Paul then insists, "This is the truth, and no lie."

Consequently, there is no cult of the saints in Protestantism. But Lutherans, Anglicans, and Methodists offer them to believers as models of faith. Alternatively, the Orthodox churches display a great veneration for the saints, beginning of course with Cyril (originally Constantine) and Methodius, his elder brother (originally Michael). These two sons of a high-ranking Byzantine bureaucrat had abandoned their profession and withdrawn to a monastery. In 860 the Byzantine emperor, who had his own political aspirations, gave them the task of spreading the word of God to the Slavic peoples in Central Europe and north of the Black Sea. In these regions, Germanic priests were trying to teach Christianity in Latin to the local population, but these people had no Latin and could not even write their own language. To evangelize them, an alphabet had to be created first, and so the two brothers invented one. The letters were called Cyrillic and were based on Greek letters, and then inflected with special signs to create the sounds that did not exist in Greek. The mission staged by Cyril and Methodius (whose name means "he who travels with") met with obstacles, but it succeeded in expanding the Orthodox Church and the cult of saints into the broad lands to the east.

These conversions took place after the Iconoclastic Controversy which had arisen throughout the Orthodox territories in churches as well as in homes. The icon of icons was of course Jesus Christ, as the human manifestation of God. He and the saints were almost always represented full faced, since the icon was a conduit from the visible to the invisibility of the Holy Spirit.

In the seventh century the cult of the saints was assimilated into the practice of idolatry. As such, it was fiercely resisted; even the image of Christ himself was forbidden for a time. This interdiction—or iconoclasm—was more or less enforced until the first half of the ninth century, when it disappeared, just before Cyril and Methodius arrived on the scene. The cult of the saints, which had actually never ceased, was revived and is still widely practiced in Orthodoxy.

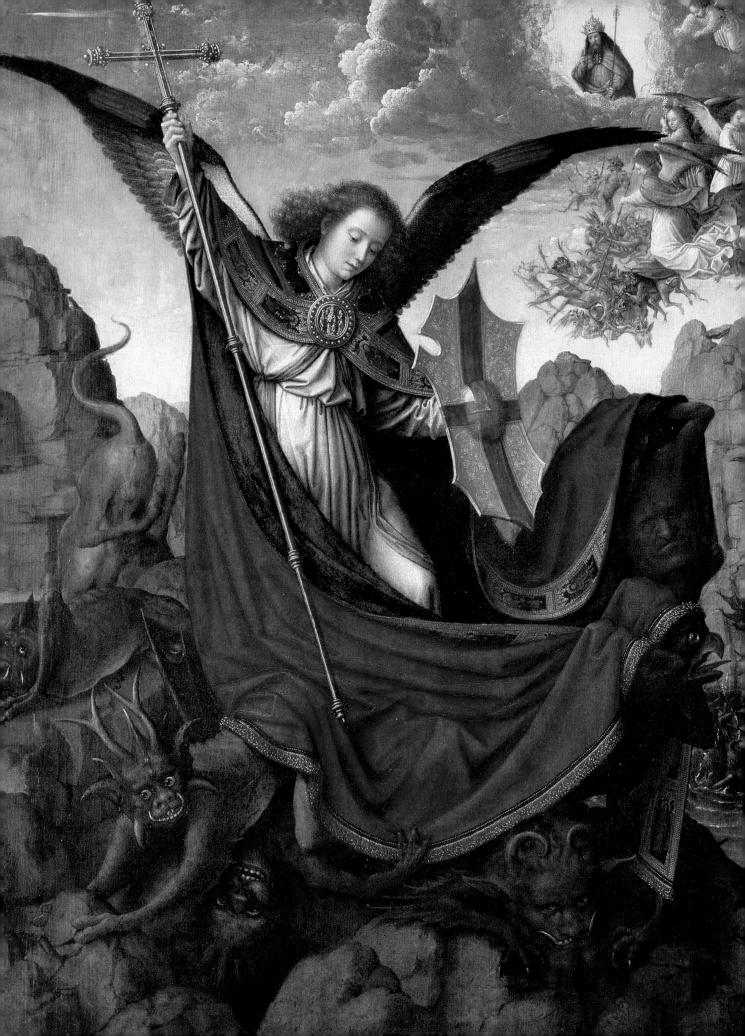

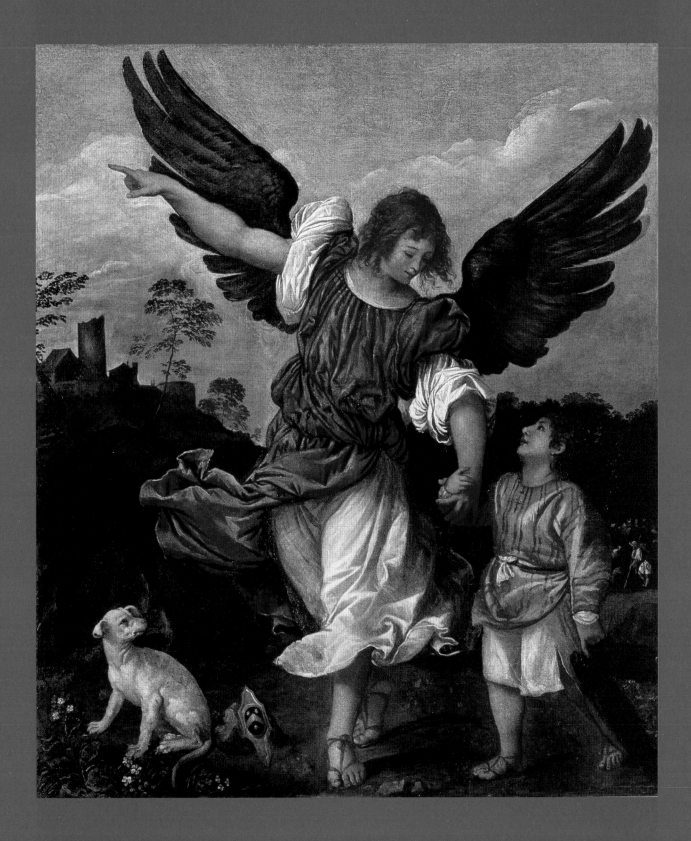

It is not practiced in Islam, one of the other great monotheistic religions. Above all, the Muslim must "submit" to God. He or she would never consider sharing in God's nature, on earth or elsewhere. Islam is a personal spiritual path on which the believer is invited to respond to the Word of God, which is the Koran. Through this complete submission, the believer follows in the steps of Abraham, Moses, Joseph, Jesus, and His disciples. Any reference to the saints of Islam is directly influenced by Christian vocabulary: these were God's friends and allies, whom He protected. As such, these men were revered and considered as models of the faith, but not as saints.

As we shall now see, the history of the saints is first and foremost a Christian history that does not, however, cast doubt on the human yet spiritual dimension of other exemplary believers in other religions.

Hossein Naqqash,
Raphael,
1590.
Musée Guimet, Paris.

Christ's
Entourage

As we have just seen, the very first Christians called each other "saints." They certainly deserved the title, not only because some were martyrs, but because in their daily life they were forced to suffer physical injuries and mockery. This was because their faith seemed so revolutionary, even though they continued to pray in the synagogues in the early days.

Among Jesus' contemporaries, His mother Mary is the most important. Curiously, the Evangelists do not refer to her often by name (less, for instance, than to Mary Magdalene), and her origin is not mentioned; the only other such figure in the Bible is Sarah, Abraham's wife. In speaking of Mary, the four evangelists prefer to call her "the mother" of Jesus—already a very significant epithet—or else as "Joseph's wife." Among the four, it is Matthew who, along with Luke, mentions her most often, although he does so in only seventeen verses.

We can learn a bit more from the Apocryphal evangelists, whose texts were written mainly in the second and third centuries of the Christian era. The Church contests their authenticity, but their authors were ardent Christians who strove to spread their faith so fervently that they sometimes excessively increased the number of awe-inspiring or miraculous episodes.

Sandro Botticelli,
The Madonna of the Magnificat (detail),
c. 1483–85.
Galleria degli Uffizi, Florence.

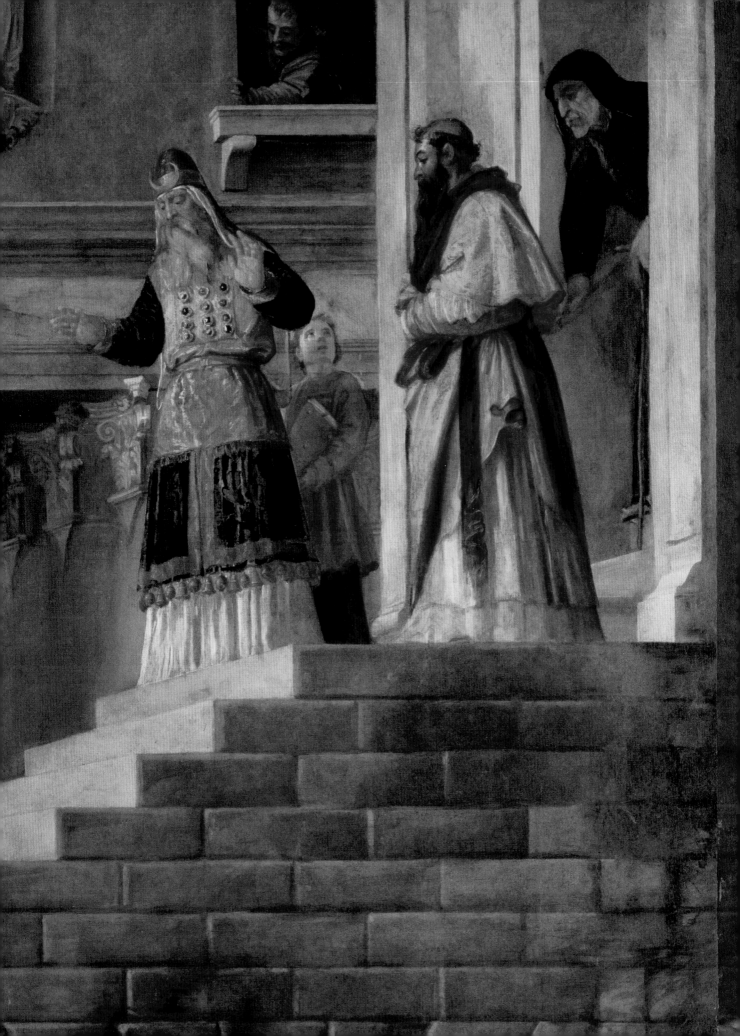

We know Mary's parents, Anne and Joachim, through the Proto-Evangelion of James, written in the late second century. The Church considers them saints and celebrates them together on July 26. Like many significant women in the Old Testament, Anne was sterile and this saddened her. Joachim withdrew to the mountains with his flocks until the day an angel announced to him that it was time to return to his wife. The same angel had already told Anne that she was no longer sterile. Husband and wife met again at the "Golden Gate," which is often represented in art. The cult of Saint Anne did not develop in the west until the time of the Crusades, and Anne of Austria, the wife of Louis XIII, cultivated it after the birth of Louis XIV. The cult was popular in Brittany, where a wooden statue of the saint that had been buried was discovered (and later destroyed during the Revolution), and in Quebec. Joachim is less celebrated, but his name is often given to children.

Stories about Mary's childhood with Anne and Joachim have been told in many texts and sermons and have inspired the greatest artists, contributing extensively to the cult of Mary. Titian painted the young girl boldly ascending the steps of the temple in Jerusalem and Rainer Maria Rilke described her in his cyclical poem *Das Marien-Leben* (The Life of Mary, 1912) as she ran away from her parents:

> But she slipped between them,
> So small, and ran from their hands
> To embrace her destiny that, higher than the Temple,
> Was already more perfect than that House.

"More perfect than that House" because Mary, whose cult continued to grow as the Catholic faith expanded, was proclaimed Theotokos or mother of God in the third century, then "immaculate" in the nineteenth century, and was finally ascended "officially" to heaven by Pope Pius XII in the twentieth century. Pius recognized the old belief that the body of the woman who bore Jesus was without sin. This is different from Christ's resurrection: Jesus ascended to heaven through His own power, while Mary was elevated by her son's power.

pp. 32-33:
Titian,
**The Presentation of the Virgin
at the Temple** (detail),
c.1534–38.
Galleria dell'Accademia, Venice.

Facing page:
Giotto di Bondone,
Joachim's Dream (detail),
c.1303–05.
Scrovegni Chapel, Padua.

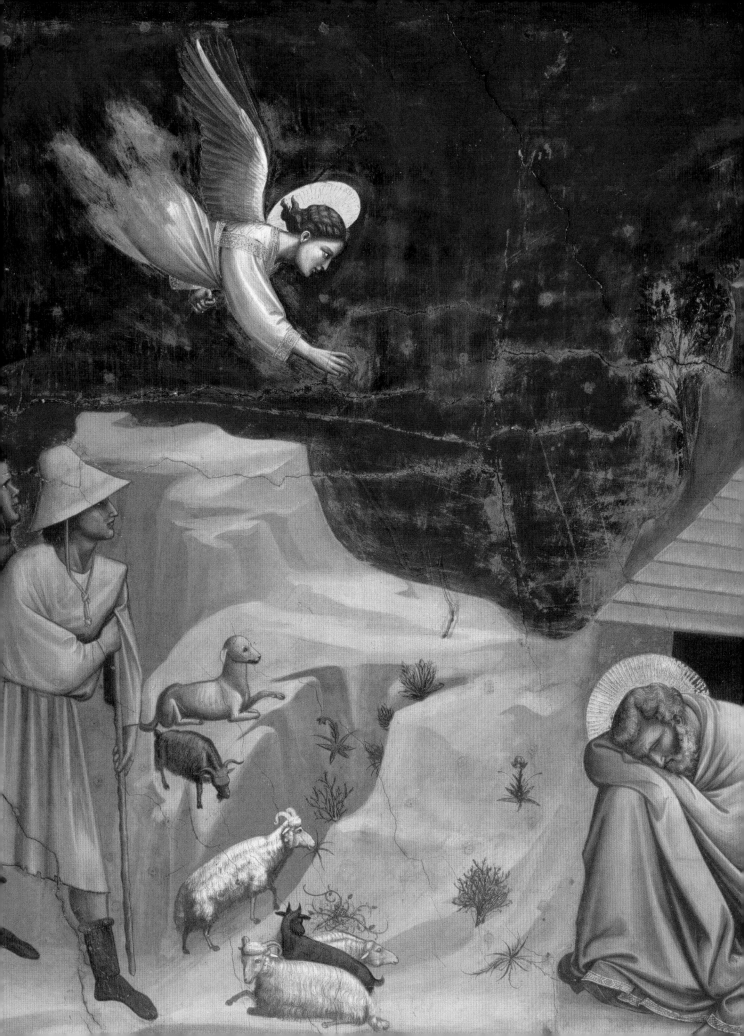

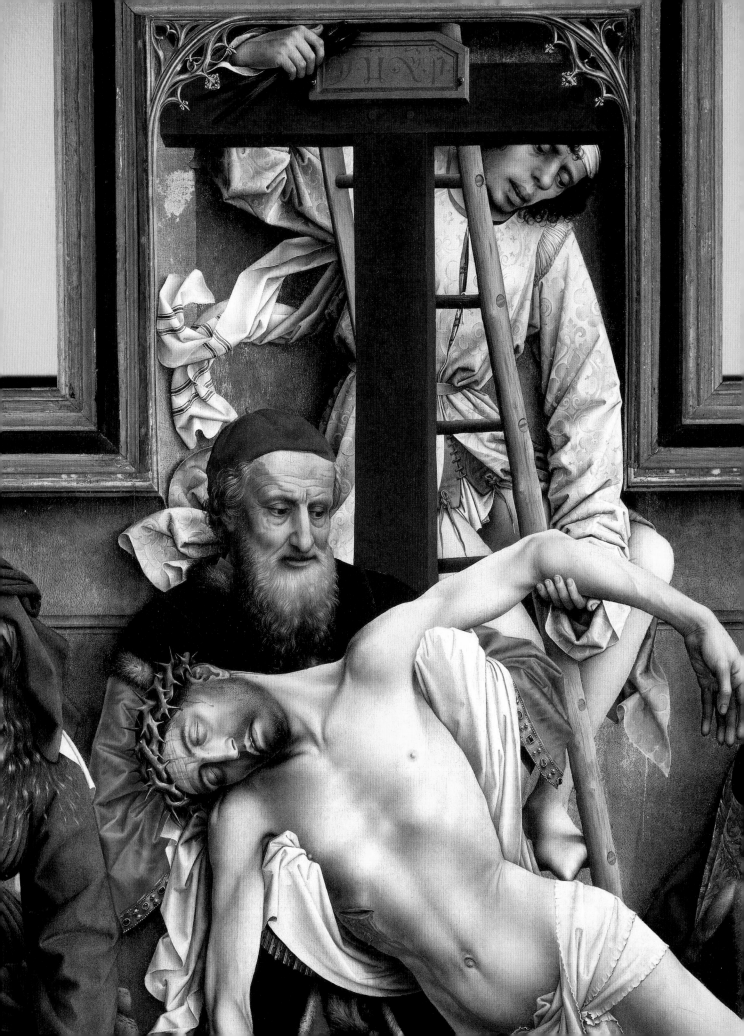

Little is known about Mary and Jesus' daily life for thirty years, with the exception of the episode when Jesus was in Jerusalem with his parents and ran off to speak with the wise men in the temple. But we can certainly imagine the character of the woman who day after day raised a boy—and then the man who would change the course of history—with her words and smiles, occasional scolds, her teaching, and ultimately her very being. She would question His sermons, whose words broke with the rabbi's teaching and sometimes caused her pain, as in the well-known episode when she was in Capernaum while Jesus was preaching and heard these words: "For whoever does the will of God, he is My brother and sister and mother" (Mark 3:35). But she kept love and hope in her heart, since the mother of such a boy could only be an exceptional, enlightened woman. She also traveled with him. A line in the New Testament describes her with the Apostles after Easter, saying that they were "continually devoting themselves to prayer, along with the women, and Mary the mother of Jesus, and with His brothers" (Acts of the Apostles 1:14).

Mary was at the heart of this small community, although she lived in a man's world. In particular, men took charge of children's religious education then. Thus it was Joseph, who is hardly mentioned by the Evangelists (probably because he died when Jesus was a teen), who took the boy to the synagogue, where women were admitted only in a separate gallery. Joseph also gave Jesus his name, a momentous act among the Jews at the time, also showing authority. The inhabitants of Nazareth, a small village of houses huddled together, called the boy Jesus-ben-Joseph. Joseph taught the boy to be a carpenter, which was his own profession; he was a man of standing in a world where there were many indebted peasants and unemployed people, to judge from Jesus' parables, which provide significant information on daily life.

Many Catholics respect and venerate Joseph, naming their children after him, and statues of Joseph often adorn places of worship. About a dozen other saints also bear his name; among them is Joseph of Arimathea, a rich man who was given permission, after Jesus was crucified, to take His body and place it in a tomb belonging to him.

There are also many Marys or Miriams on the calendar of saints. Moses' eldest sister, Miriam, is one of only four other women who are recognized as prophetesses

Rogier van der Weyden,
The Descent from the Cross (detail),
c.1435–38.
Museo Nacional del Prado, Madrid.

in the Bible. The name is probably of Egyptian origin; its meaning suggests love, which recalls Jesus' mother as well as another woman, Mary Magdalene. One of Jesus' female followers, she was very close to Him and is referred to more often than Mary by the Evangelists.

Mary Magdalene is commonly confused with the woman who, according to Luke (7:36–50), caused a scene at the house of a Pharisee who had invited Jesus to dinner. She then showered his feet with her tears before wiping them with her beautiful long hair and perfuming them. But a woman known as a sinner by the whole city would not be able to enter a Pharisee's house so easily to attend a banquet: his servants would not have let her in. Moreover, their master bid them to remove her at once. The Pharisee, whose name was Simon, was most interested in Jesus himself. "If he is truly a prophet," he thought, "then he must know that this woman is impure."

Jesus replied with a parable, the story of a man who had two debtors. One of them owed the man ten times more than the other, but both were impoverished. Jesus asked Simon which of the two debtors would be more grateful, to which Simon replied that the more indebted man would undoubtedly be more grateful. Therefore the sinful woman had shown more gratitude than Simon the Pharisee, who considered himself most pure and correct in God's eyes, since he scrupulously

Right:
Austrian School,
Noli me tangere
(detail),
c. 1331.
Klosterneuburg
Monastery, Austria.

Facing page:
Carlo Dolci,
***The Repentant
Magdalene***,
c. 1660.
Pavlovsk Palace,
Pavlovsk.

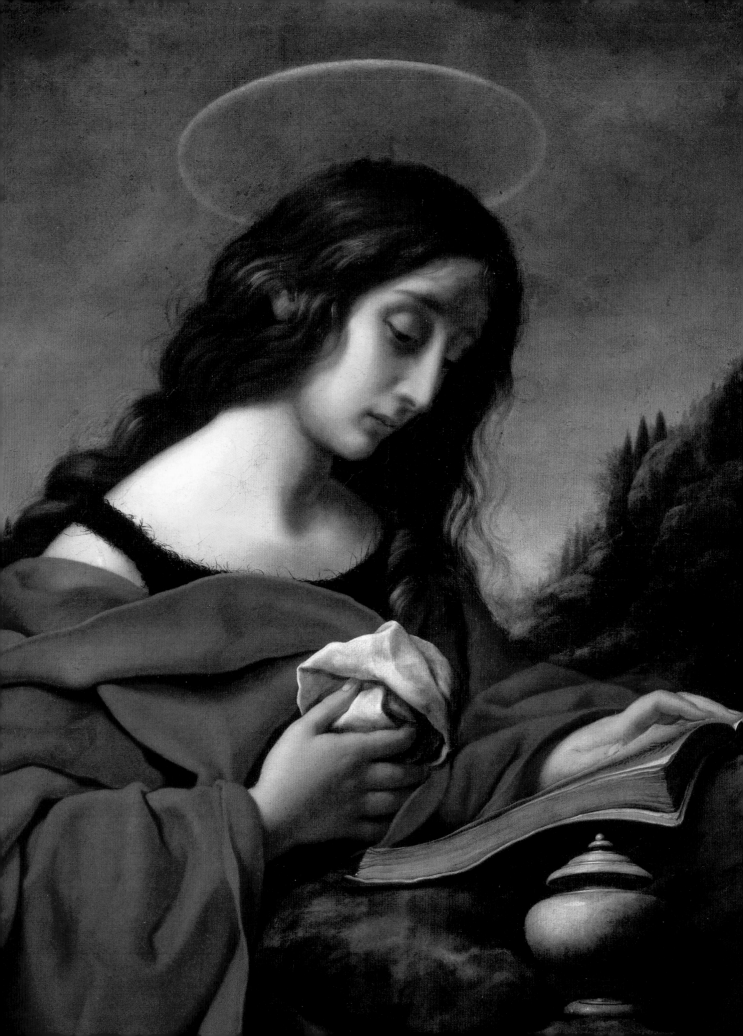

obeyed all God's commandments but was unable to show respect for the woman. She, on the other hand, had shown great humility by bathing Jesus' feet, as servants do for their masters (and as Jesus did for His disciples at the Last Supper).

There is no proof that the "sinner" in this parable is Mary Magdalene. Furthermore, many New Testament scholars conjecture that the whole story is a parable, one suggesting that scrupulous observation of God's law—without a deep faith and love—is not enough.

But the scenario of Mary Magdalene as a former public sinner converted by Jesus' teachings proved too tempting; it has seduced many artists, pseudo-historians, and imaginative preachers. There have also been some claims that Magdala, a small town near Capernaum on the shores of the Sea of Galilee, was a place where loose morals abounded. But in fact very little is known about Mary Magdalene, except what Luke has written. He writes that seven demons emerged from her, without indicating that this was Jesus' doing or specifying which demons or how they were expelled. We should recall that many contemporary scholars interpret the expulsion of demons as a reference to the healing of epileptic seizures.

The essentials of what we know about Mary Magdalene are found elsewhere, Obviously key is her role during Christ's suffering and resurrection. On the evening of Christ's death, when the crowd and His disciples had withdrawn, she remained with a few other women at the foot of the cross, transfixed with sorrow, as if they were waiting, beseeching the immortal man to cry out, speak, or give some sign of life. They also followed Joseph of Arimathea when the Romans gave him permission to place Jesus' body in his own tomb. More than the others, it was Mary who, mad with impatience, ran at dawn two days later to attend to the body that had been so hastily entombed, and if possible to see the martyr once again. But she did not find him there. The rock that closed the tomb had been moved away and Jesus' body was no longer inside. She ran to tell Peter who, thinking perhaps that Jesus' enemies had enacted some new villainy, confirmed that she was not dreaming and that the tomb was empty. He left the tomb; any thought that Christ had risen was far from his mind.

Mary Magdalene saw two angels; she told them simply that her Lord had been "taken away." Then she turned and saw a man whom she took for the gardener at

Pietro di Francesco degli Orioli,
The Calling of Peter and Andrew (detail),
c. 1494–95.
Galleria dell'Accademia, Venice.

first and accused him of taking away the body. But Jesus addressed her by name: "Mary." Suddenly recognizing him, she cried *"Rabbouni!"* The word *"rabbi"* means "master," as the Evangelist John, who relates this marvelous scene, affirms. But he does not tell us that the diminutive form *"Rabbouni"* introduces an affectionate note.

When Mary related the scene of the Resurrection, the foundation of Christianity, to the reconvened disciples, they were at first skeptical, and possibly jealous. After all, she was only a woman. An Apocrypha from the second century called "The Gospel of Mary" presents her with Peter and a few disciples. They interrogate her about Jesus' words to her of which, they stress, they are unaware. Mary launches into a long and complicated speech. Andrew, Peter's brother, then asks, "Is it possible that our Teacher discussed matters that we are unaware of with a woman?"

It seems that Andrew was also unaware of Jesus' conversations with another woman, Mary of Bethany, a small town near Jerusalem, where Lazarus and his

two sisters, Martha and Mary, lived. When her brother died, Martha sent for Jesus. According to the gospel of John (11:27), upon his arrival, she was the first to recognize that not only a prophet, he was also the Messiah: "Yes, Lord; I have believed that You are the Christ, the Son of God, even He who comes into the world." Martha also ran an active, hospitable household. When Jesus entered their house, Martha bustled about, while Mary was more attentive to their guest's words and to washing his feet than to helping the servants. When Martha (whose name means "mistress" in Aramaic) reproached her sister as she scurried from room to room, Jesus remarked that "Mary was wiser" to prefer his instruction to household duties.

Many other saints in the same period are called Mary—for instance, the mother of the Evangelist Mark who, before writing his gospel in Rome around 60 CE, accompanied the apostle Paul on his first missionary journey. Merchants brought Mark's relics to Venice, and he became the patron saint of the city. He was one of Christ's disciples and his mother, Mary, who was a widow, welcomed the first meetings of Christians into her home in Jerusalem, a sign of great courage and faith. But this Mary is often forgotten, like Joanna, who often endangered herself to help Jesus and his companions. She was the wife of Chuza, the steward of Herod Antipas, one of the sons of Herod the Great, tetrarch of Galilee. This aristocratic woman who sometimes followed Jesus was among the women who helped him "with their possessions," according to Luke. We can imagine the trouble she encountered

Right:
Vincent van Gogh,
***The Raising
of Lazarus***
(after Rembrandt),
1890.
Van Gogh Museum,
Amsterdam.

Facing page:
Jan Vermeer,
***Christ in the House
of Martha and Mary***
(detail),
before 1656.
National Gallery
of Scotland, Edinburgh.

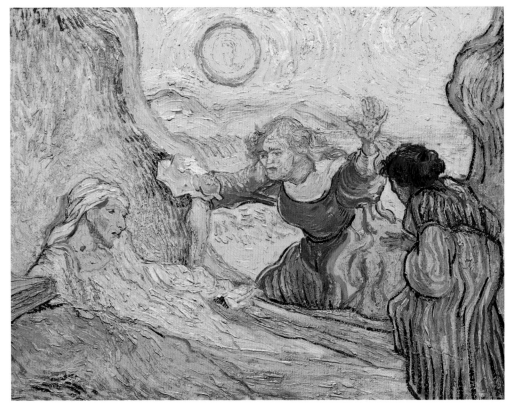

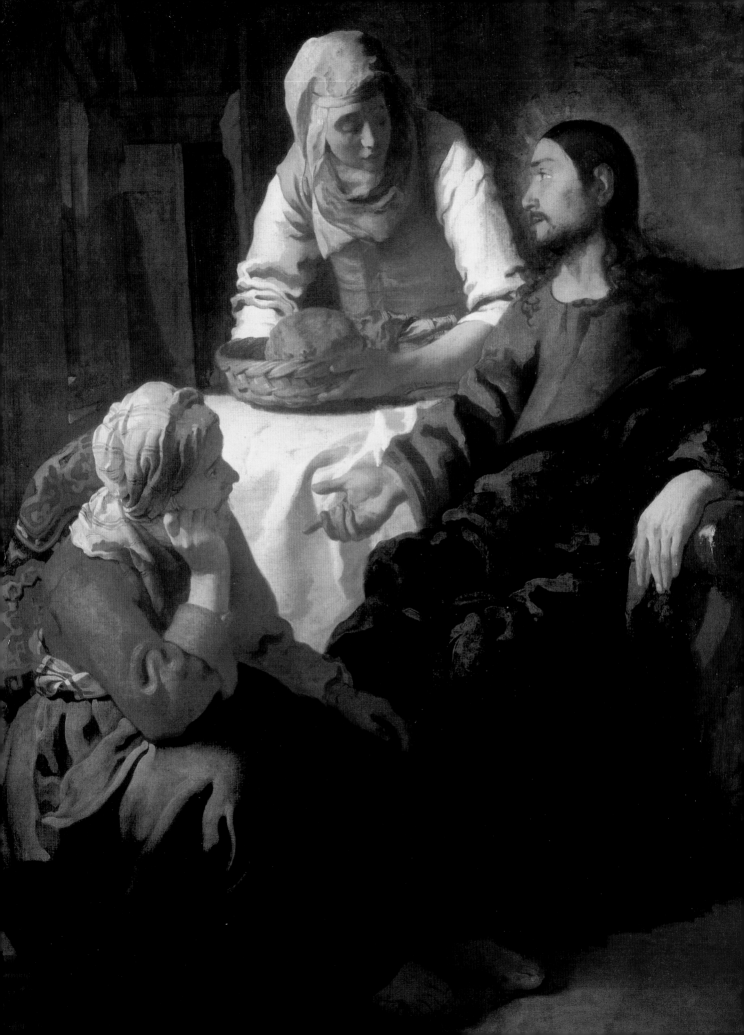

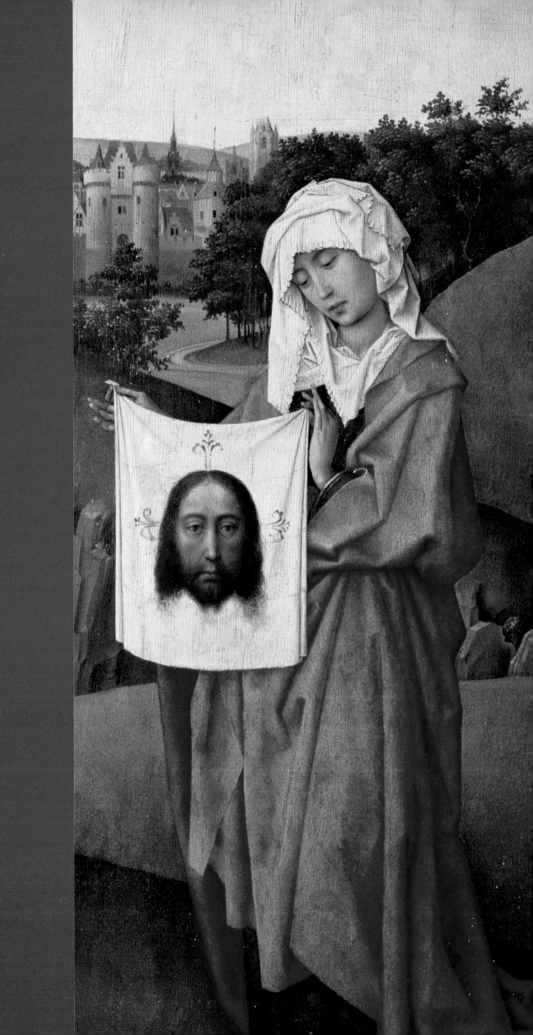

and the risks she took until the end, since she was among the women who went with Mary Magdalene to the tomb on the third day, bringing myrrh and other spices. She also ran with her to announce the resurrection to the apostles, to whom their testimony sounded like "nonsense" (Luke 24:11). Why authors of biographies of legendary saints have not been more interested in this Joanna is a mystery.

In the early centuries of the Christian era, the cult of saints recognized by the clergy and the people was not widely developed. Mary Magdalene's own faction did not begin until the end of the first millennium and was often handed down through legends.

One of these tales relates that she sailed to Provence, accompanied by two other Marys, and landed near the church called Notre-Dame-de-la-Mer, whose name was changed to Saintes-Maries-de-la-Mer. Since their servant woman, Sarah, had tan skin, it was assumed that she was from a gypsy tribe. As a result, the place became a celebrated place of pilgrimage for gypsies.

The women who followed Jesus are the best-known female saints. Another woman, who is often referenced and represented, is Veronica, although she does not appear in either the Gospels or the Acts of the Apostles, but in a text from the fourth or fifth century whose exact origin is not known. Often depicted as a young woman, she was at the side of the road as Christ, tormented by the soldiers, climbed to Calvary bearing his cross. Overcome with pity, she removed her veil and wiped Christ's face. Jesus, touched by her kindness, left the mark of his face on the cloth in gratitude. The image on the veil that has been reproduced in so many forms has not been preserved, and we do not know the origin of Veronica's name.

Some researchers have pointed out that the Greek word *eikon* means "image" and have coupled it with the Latin *verus*, meaning "true." Nothing factual is known about this episode, but we may discern a beautiful symbol here that represents all the anonymous souls who were compassionate over Christ's suffering. Two other Veronicas were also recognized as saints by the church. One, Veronica Giuliani, was an Italian nun; the main thing known about her is that the bishop who gave her the sacrament of confirmation in the seventeenth century prophesied that she would become a saint. The other, Veronica of Binasco, was also a nun and

Rogier van der Weyden,
Saint Veronica and the Veil
(detail from the *Crucifixion Triptych*),
c.1440.
Kunsthistorisches Museum, Vienna.

lived with the Augustine sisters in Milan. These women were unkind to her because she was illiterate and made her beg in the streets to contribute to the convent. It is said that several miracles marked the course of her life.

We must now return to the first century and recall Jesus' disciples who were canonized by the Church, noting that many of the apostles, beginning with Peter, were originally John the Baptist's disciples.

For most historians, Jesus' public life is framed by two figures whose existence is attested to by both Christian and non-Christian texts: John the Baptist, who was a saint, and Pontius Pilate, who obviously was not. Specialists often disagree, however, on the circumstances and teachings of the son of Elizabeth, who was Mary's cousin.

The Gospel of Matthew describes him as a moralizing preacher-prophet who lived in the wilderness on the banks of the Jordan. He called the Jews who came there to be baptized a "band of vipers," adding that God's anger—which most often in biblical texts took the form of an all-consuming fire—would soon destroy them. Neither baptism nor their descent from Abraham would suffice to save them. On the contrary, this lineage made them somewhat arrogant, a quality that was often deplored by Israelite prophets like Amos and Jeremiah.

What made John different was that he preached an end to his listeners that would also be a beginning, announcing, "As for me, I baptize you with water; but One is coming who is mightier than I, and I am not fit to untie the thong of His sandals; He will baptize you with the Holy Spirit and fire" (Luke 3:16).

Who was this person who would follow John but be stronger than him? God does not wear sandals, and John's Jewish audience could not yet imagine God as a man or in any human form, although Jehovah had appeared so long ago in the time of the patriarchs. It was of Jesus that the Baptist was speaking, as was stressed in the Gospel of another John (whom we shall meet later) when he was struggling with disciples of the Baptist who refused to become Christians. So Jesus came to be baptized by John and stayed long enough among his companions to meet Andrew and others who then followed him. And when John was in prison, Jesus said of him, "Truly I say to you, among those born of women there has not arisen anyone

Simone Camaldolese,
The Baptism of Christ (detail),
c. 1380.
Church of Santa Croce, Florence.

greater than John the Baptist. Yet the one who is least in the kingdom of heaven is greater than he" (Matthew 11:11) because John was only his antecedent and had not yet entered the kingdom of heaven.

As theologians confirm, Jesus and John preached independently of each other until the day the Baptist, who was indignant at Herod Antipas' conduct because he was living with his brother's wife, Herodias, began preaching against him. He was then thrown in prison. Herodias hated him and wanted to have him put to death. But the king could not decide, because he was afraid of the people's reaction. Moreover, according to the Gospel of Mark (6:20), the sovereign himself was somewhat interested in hearing John's sermon. But then, on the day Herod celebrated his birthday with a great banquet, a very beautiful and graceful young woman danced before him. This was Salome, Herodias' daughter. Not knowing her identity, the king asked her what gift she would like for her performance. The modest dancer consulted her mother who quickly instructed her to ask for John the Baptist's head on a platter. The king, "very sorry" (Mark 6:26), could not go back on his word before the courtiers attending the banquet. So he ordered a guard to cut off John's head.

This is how the saint who prefigured Jesus died. The church made June 24 his feast day, at the outset of the summer solstice when the days begin to grow shorter because, according to the gospel of John, in speaking of Jesus, the Baptist declared, "He must grow and I must decline," in recognition of Jesus's immense superiority.

His cult became so widespread that Baptist became a first name. Other saints bear the name, notably Saint Jean-Baptiste de la Salle, who established the order of the "Brothers of the Christian schools" in the seventeenth century. The mission of these brothers was to devote themselves completely to teaching the middle and working classes. For this reason, they were not allowed to become priests, at a time when those who were had many privileges. The Christian Brothers institution quickly spread throughout the world, especially the United States.

Let us now return to the first century CE and recall the apostles who were sainted. First of all, we know nothing about several of them; however, at least three of them are mentioned in the lists of the Twelve found in the New Testament. First Bartholomew, who is sometimes confused with Nathaniel, one of John the

Baptist's disciples who was referring to Jesus when he asked if "anything good could come out of Nazareth." But he finally became one of his followers. Then we have Judas, the son of an unidentified James. He might be the Judas who was not Iscariot, the one who according to John (14:22) asked Jesus a question at the Last Supper. Finally we have James, the son of Alphaeus, but nothing is known of Alphaeus. At that time the Jews had a small range of given names, and James (Jacob) was a very common one.

We know a little more about Philip, although he only appears in the final gospel of John, which is a composite of many successive versions. This gospel clearly confirms Jesus' divinity and gives the most details about where he preached. Philip lived in Bethsaida, Andrew and Peter's town, before becoming John's disciple. The Greek pilgrims who had come to Jerusalem for Easter asked Philip to introduce them to Jesus, which leads us to believe that he knew Greek (Philip is after all a Greek name). Philip was also the one who said to Jesus during the Last Supper, "Show us the Father, and that is enough," meaning that they recognized Jesus as the Son of God.

The apostle Andrew and his brother Peter were Philip's companions. Jesus called upon this trio to become "fishers of men" when they cast their nets into the sea. Like Andrew and Philip, Peter was one of John the Baptist's followers, but he was called Simon then. Jesus later called him "Képa" in Aramaic, which means "rock" or "stone." Peter appears first in all the lists of the Twelve in the gospels, and he is often the one, as head of the apostles, who questions Jesus. As a leader, he lacked courage at the time of Christ's passion, but he was also, with Mary Magdalene, the first witness of the resurrection.

Peter became head of the Church of Jerusalem in its early years and was often put in prison because of his leadership. He then left Palestine to become a missionary in Antioch and Corinth and, according to ecclesiastical tradition, died a martyr in Rome during Nero's reign, in around 60 CE, on the Vatican hill where the famous basilica was built in his name.

Many Christians received the name Peter at baptism, and the Church made saints of some of them. Saint Peter Canisius, a fifteenth-century Jesuit who was given the title of Apostle of the Germans, was one of them. Saint Peter Fourier,

pp. 50-51:
Stephanus Garsia,
The Twelve Apostles,
from Beatus of Liebana's *Commentary on the Apocalypse*,
1060(?)-70(?).
Bibliothèque Nationale de France, Paris.

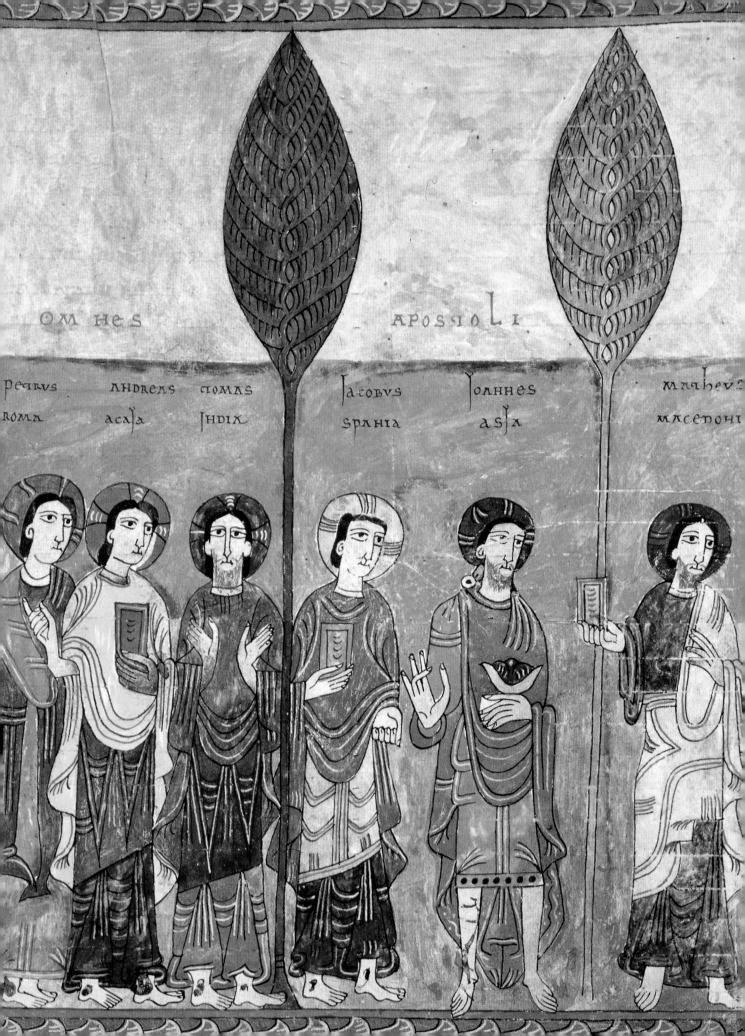

OMNES APOSTOLI

PETRUS ANDREAS TOMAS IACOBUS IOHNNES MATHEVS
ROMA ACAIA INDIA SPANIA ASIA MACEDONI

SIMVL IHVHVM ETPA TRIA SORTI TI SVHT

FILIPVS BARTOLOMS SIMON ZELOTES IACOBVS FRTR PAVLVS C
GALLIAS LICAOHIA EGIPTVS DHI IHRLM CTERIS
 APSOLIS

originally a simple parish priest who later played an important role in Lorraine's relations with France; he was the butt of Richelieu's hostilities, which forced him into exile in Franche-Comté.

Among Jesus' other close companions we find Thomas, who is mentioned only once—like Philip—in the Gospel of John, besides in the lists of the Twelve. He is traditionally called Doubting Thomas. But this same skepticism, which did not prevent him from following Jesus, enabled him to affirm his faith even more strongly in two scenes that are of prime importance for Christians.

The first occurred during the Last Supper. Jesus has just stressed that his companions know the path that he is taking. Thomas replies, "Lord, we do not know where You are going, how do we know the way?", to which Jesus replies, "I am the way, the truth, and the life" (John 14:5–6).

The other scene that earned Thomas his epithet took place after the resurrection. Thomas was not present at Jesus' first reappearance to his disciples, so when Thomas joined his companions, he refused to believe what they told him. He proclaimed, "Unless I see in His hands the imprint of the nails, and put my finger into the place of the nails, and put my hand into His side, I will not believe" (John 20:25). Eight days later, Jesus returned to see them in a house where all doors were locked, and he invited the skeptic to put his hands into his side. Thomas then bowed down and pronounced one of the key lines of Christianity, "My Lord and my God!" a theological lightning bolt that declared his faith in God-made-man.

Of course the Church has granted sainthood to other Thomases, including Thomas Aquinas and Thomas Becket, whom we shall meet later.

Also among the Twelve was a certain Simon the Canaanite (not the one who would become Peter), who was also called the Zealot. The Zealots were resistance fighters who opposed the occupying Roman forces. But they only took up arms after the destruction of the Temple around 60 CE. This anachronism can be explained by the fact that the term was applied to the strictest Israelites who, in their zeal to apply Jewish law, even executed other Jews whom they held to be unfaithful to the law of Moses. Such cases were few and directed against so-called Jewish apostates. The apostle Paul considered himself a "zealot of God." It is probably in this sense that the term was applied to Simon, indicating above all that Jesus was addressing

Caravaggio,
***The Incredulity
of Saint Thomas*** (detail),
c. 1595–1600.
Sanssouci Palace, Potsdam.

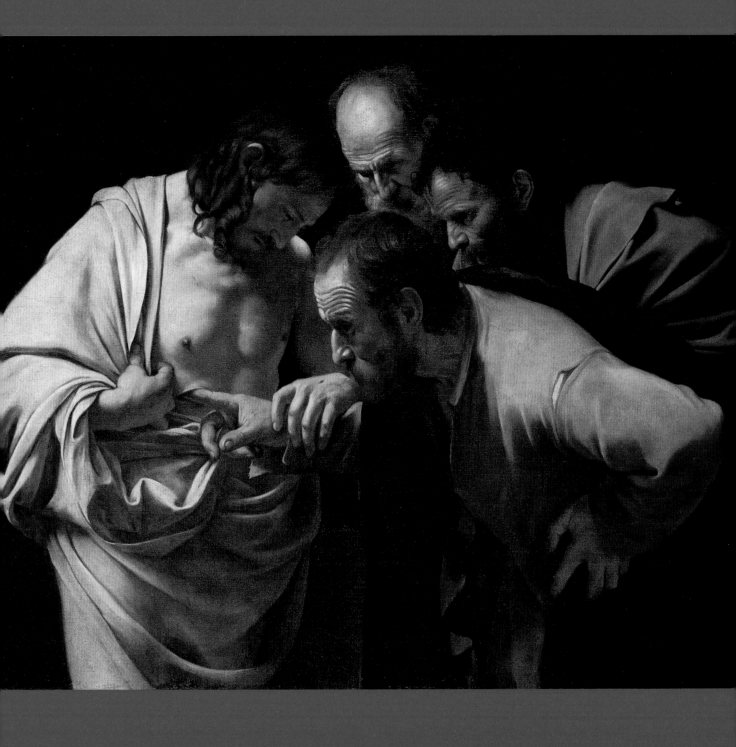

all the Israelis, including the tax collectors and potentially violent rigorists. Some extremists went so far as to describe Jesus as "a gluttonous man and a drunkard," a friend of the publicans (petty bureaucrats, especially tax collectors who worked for the Romans) and sinners (Matthew 11:19), with whom he did not refuse to break bread. This is because Jesus wanted to bring together all of Israel, and all of humanity by extension.

Another indication of his desire to gather as many as possible into his flock was the presence of James and John, sons of Zebedee, a master-fisherman who had his own business (which suggests he was well-to-do). The fishing industry on the Sea of Galilee was prosperous, at least for proprietors. The fact that James and John were close to Jesus indicates that he did not call only the poor to follow him.

James and John were busily mending their father's nets when Jesus called them. According to the gospels, the two brothers were inseparable, so they followed Jesus together. Jesus soon began calling them *bonaerges*, which literally means "son of thunder." The name provoked many questions. Why this name? Gospel scholars suggest that the two brothers were hotheaded and high-spirited; they certainly did not lack ambition. In fact, one day they asked Him to give them the two seats nearest him, at His right and left, when His reign began in heaven.

Jesus and His disciples then went up to Jerusalem; He had warned them of the risks He was taking in going there. Had the two brothers understood nothing? He avoided their request with this mysterious question: "Are you able to drink the cup that I drink, or to be baptized with the baptism with which I am baptized?" (Mark 10:38.) The complete context of the question indicates that this will be a chalice of suffering. This was accurate in James's case; he was the first of the Twelve to be martyred by Herod Agrippa I, about ten years after Christ's passion. He was later called James the Greater (although he is never called by this name in the New Testament), probably to distinguish him from James the Less, about whom nothing is known, except that his mother, Mary, is mentioned among the women gathered at the foot of the cross. Together with Peter, John was a leader of the first Christian community in Jerusalem.

According to a tradition that sprang up in the seventh century, John spread the Gospel to Spain. After his death, his body was abandoned on the riverbank, and

Marco Basaiti,
Calling of the Sons of Zebedee,
c. 1515.
Gallerie dell'Accademia, Venice.

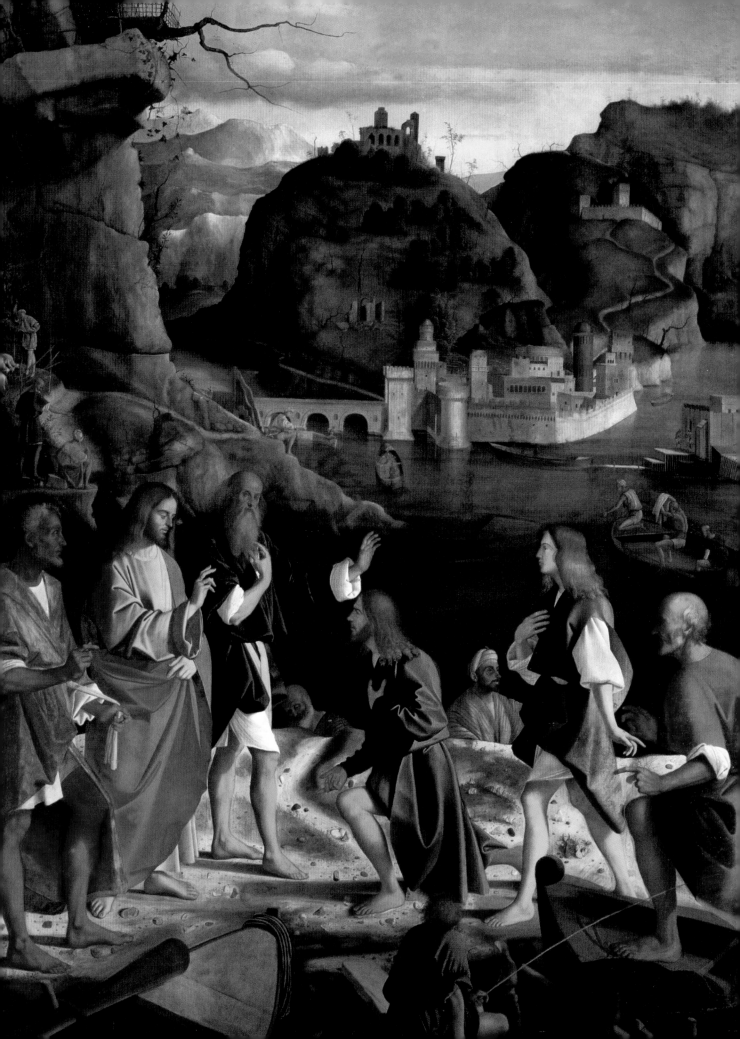

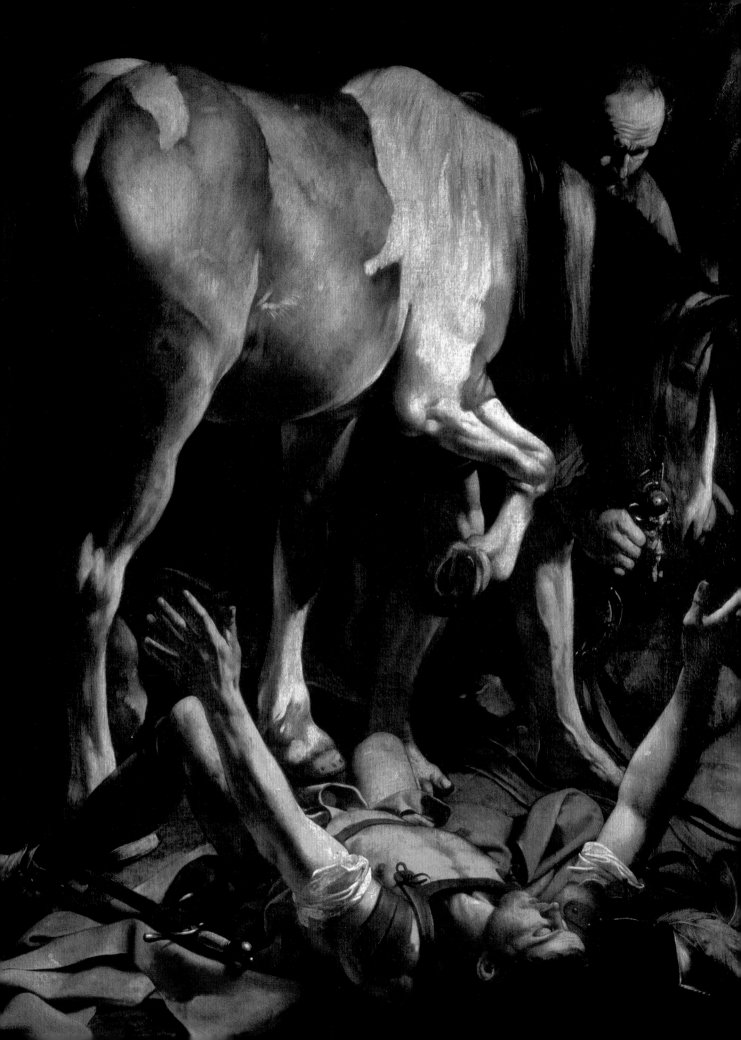

when his companions came to bury him, they saw a boat in full sail ready to depart. They took the body on board and the crewless ship set out and crossed the Mediterranean all the way to Spain. James's friends buried him in a field there, where centuries later a shepherd guided by a star discovered the tomb and the body of the sainted martyr. The place was called *campus stellae*, or the field of the star, from which the name Compostela is derived, the destination of the famous and popular pilgrimage. But the story supposed that James was resuscitated before being buried in Spain. His martyrdom, however, which was ordered by Herod Agrippa I, is confirmed by all scholars of the first century CE.

His brother's lot on earth was more fortunate, since he was one of the leaders of the first Christian church in Jerusalem. He is sometimes confused with "the disciple that Jesus loved," but no passage in the New Testament confirms this supposition. Given the paucity of information about John (although we are sure that he was sainted), we shall make no further mention of him here, but instead turn to Paul, who was not one of the Twelve but who always claims the title of saint in his letters to the Christian communities he established and led, including the Galatians, the Corinthians, the Romans, and the Ephesians.

The life of this great missionary is well known. He relates his own conversion to the Jews of Jerusalem and to King Agrippa, Herod the Great's successor. His companion, the Evangelist Luke, continues his narrative, relating his struggle against the Christians in Jerusalem, "strongly approving their death," and his departure for Damascus, bearing a letter from the high priest authorizing him to bring back in chains anyone he found there. Luke also tells us that Paul was "dazzled by a divine light, brighter than the sun" that stunned and struck him down; he describes his conversation with Jesus, who made him a Christian devoted to spreading the faith and guiding, sometimes with a strong hand, the communities he created throughout the empire, from Salonica to Athens, and from Rome to Crete and into Macedonia. After spending months in prison, he took up his travels again as soon as he was freed, but was arrested again and taken to Rome where he was beheaded in 67 CE. The Roman basilica of Saint Paul Outside the Walls was built on the supposed site of his martyrdom on the road to Ostia.

Caravaggio,
The Conversion of Saint Paul,
1601.
Cerasi Chapel, Church of
Santa Maria del Popolo, Rome.

Paul had an enormous influence on early Christianity, evinced by the well-known passage of his First Epistle to the Corinthians, where he writes, "Love is patient, love is kind and is not jealous; love does not brag and is not arrogant, does not act unbecomingly; it does not seek its own, is not provoked, does not take into account a wrong suffered, does not rejoice in unrighteousness, but rejoices with the truth; bears all things, believes all things, hopes all things, endures all things. Love never fails."

We cannot mention Paul without referring to Barnabas, who was called an apostle although he was not part of the original twelve. Born on Cyprus, where there was a sizable Jewish community, he went to Jerusalem and joined the first Christian community. Since it was customary for each member to share their possessions with everyone, Barnabas sold his land and gave the apostles the money he received for it. He admitted Paul into the young Christian church when some were suspicious of the former persecutor, and Barnabas accompanied Paul on his many long voyages.

Also here we must remember Luke, Paul's companion, whom he calls "gentle surgeon" in writing to the Colossians. The Church considers Luke, who was probably of Syrian origin, the author of the third gospel and a significant part of the Acts of the Apostles, which is written in a very literary Greek style. Luke tells us that the other evangelist, Matthew, was a publican who worked at the customs house and lived near Capernaum. Before renouncing everything to follow Jesus, Matthew had a celebration for his friends and acquaintances that scandalized the strict Pharisees, who could not tolerate the sight of him feasting with Roman officials.

Timothy was another of Paul's companions. Although Paul sometimes used a harsh tone in his letters, especially regarding women (whereas Jesus showed them respect and deference), he knew how to make long-lasting friends. Originally from Lycaonia, an ancient region of Turkey, Timothy was considered by Paul as his beloved son, but apparently it was his mother, Eunice, who had taught him about Christianity. Paul eventually made him an apostolic cohort, but not before he took certain precautions that demonstrate the risk he was taking. He had

Eugène Delacroix,
***Saint Barnabas Healing
The Sick*** (after Veronese),
c. 1567–70.
Musée des Beaux-Arts, Rouen.

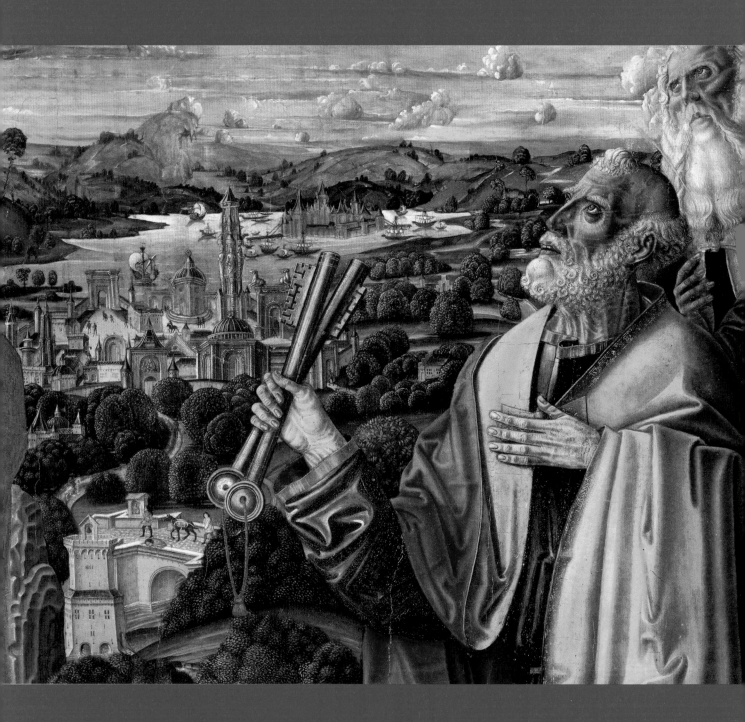

Timothy circumcised so that he would be accepted by the Jews (Acts of the Apostles 16:1–4). But this did not keep Timothy, who was almost as great a traveler as Paul, out of prison. Paul encouraged him to share in these travails as a good Christian soldier (2 Timothy 1:8).

Cornelius was a soldier and a Roman officer, an "occupier" stationed in Caesarea, where the governors of Judea lived; like Pilate, they only traveled to Jerusalem for great celebrations. The Romans were fairly discreet colonizers, but Pilate committed so many gaffes that some Jews hated him (it is true that Rome considered Judea a minor province; the best officers were not sent there). Cornelius, a centurion in the "Italic cohort," had good relations with the colonized Jews and was generous to them. This pious man "prayed endlessly to God." So God appeared to him and had him send for the apostle Simon Peter, who was not far away in Joppa. Peter had just been struck by a strange vision that he was trying to interpret when the soldiers came and took him away. Spurred by the Holy Spirit, he offered no resistance, and when he came to Cornelius, he related to him and the whole household the extraordinary adventure that he and his companions had lived out with Jesus. All his listeners were "converted by the Holy Spirit." But they were pagans in the eyes of the Jews. When Peter returned to Jerusalem, his friends rebuked him: How could he break bread with pagans? And how could he recognize them as Christians? Peter explained himself and won them over.

This anecdote, which is related at length in the Acts of the Apostles, shows that it was no easy task to persuade the first Jewish Christians that Christ's mission was universal.

Cornelius was then considered a saint. But the saint whom the Church celebrates was a pope in the third century. Like Peter, he was very open-minded toward non-Christians, and above all he was honored as a martyr, like most of the saints who were not contemporaries of Jesus.

Benvenuto di Giovanni,
Saint Peter Holding the Keys to Heaven
(detail from *The Ascension of Christ*),
1491.
Cloister of Sant'Eugenio, Siena.

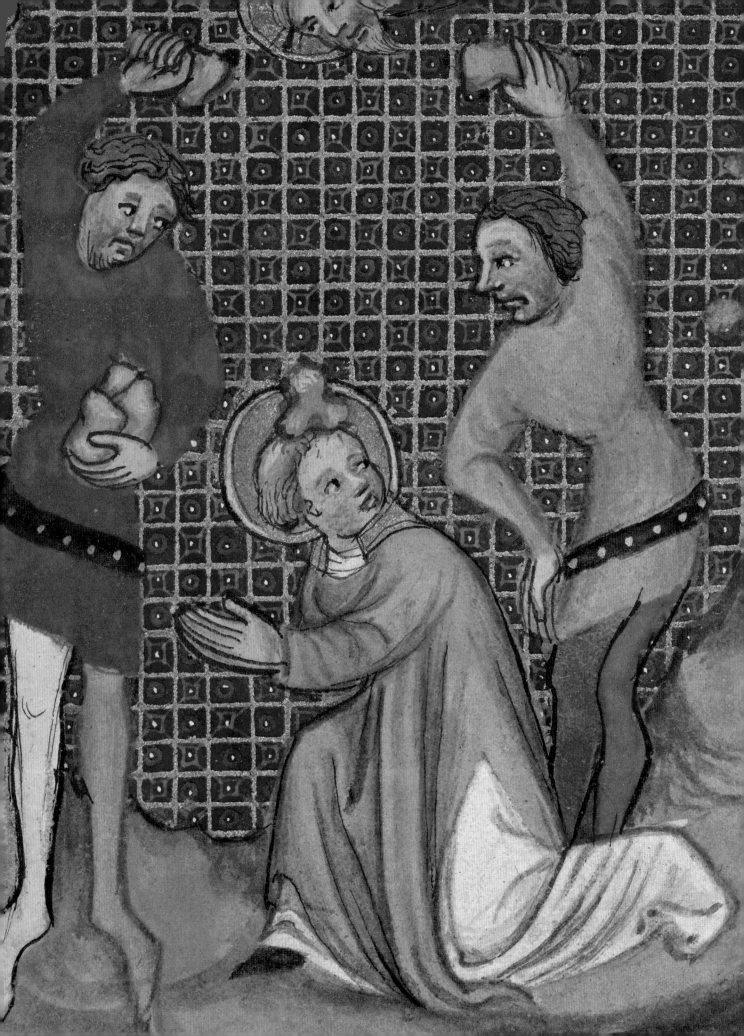

Martyrdom

Cornelius was a Hellenist. In the earliest days of the Church of Jerusalem, this was the name given to Jews who lived far from Palestine, in the area of the Mediterranean world dominated by Greek culture. Some synagogues even tolerated reading the Bible in Greek instead of Hebrew. But Hellenists were somewhat marginalized. Luke, the principal author of the Acts of the Apostles, writes that this was also true for the early Christians.

To dissipate these early dissensions, the Twelve, who still ruled the Church of Jerusalem, decided to send seven of the Hellenists on a religious mission: they should go forth and preach Christ's teachings, and tell the story of His life, death, and resurrection. And so they went. Among them, Stephen met with great success.

He "worked wonders and gave marvelous signs" among these people, especially in a synagogue where there were Jews from many different places, from Alexandria to Asia, who were affronted if not scandalized by Stephen's teaching. A few of them bribed some henchmen to bring Stephen before the Sanhedrin, the high council of Judaism, presided over by the high priest, who looked askance, as one can imagine, at the increase of what he saw as Christian dissidence.

The Stoning of Saint Stephen,
miniature from Jacobus de Voragine's
La Légende Dorée,
translated by Jean de Vignay,
1382.
British Library, London.

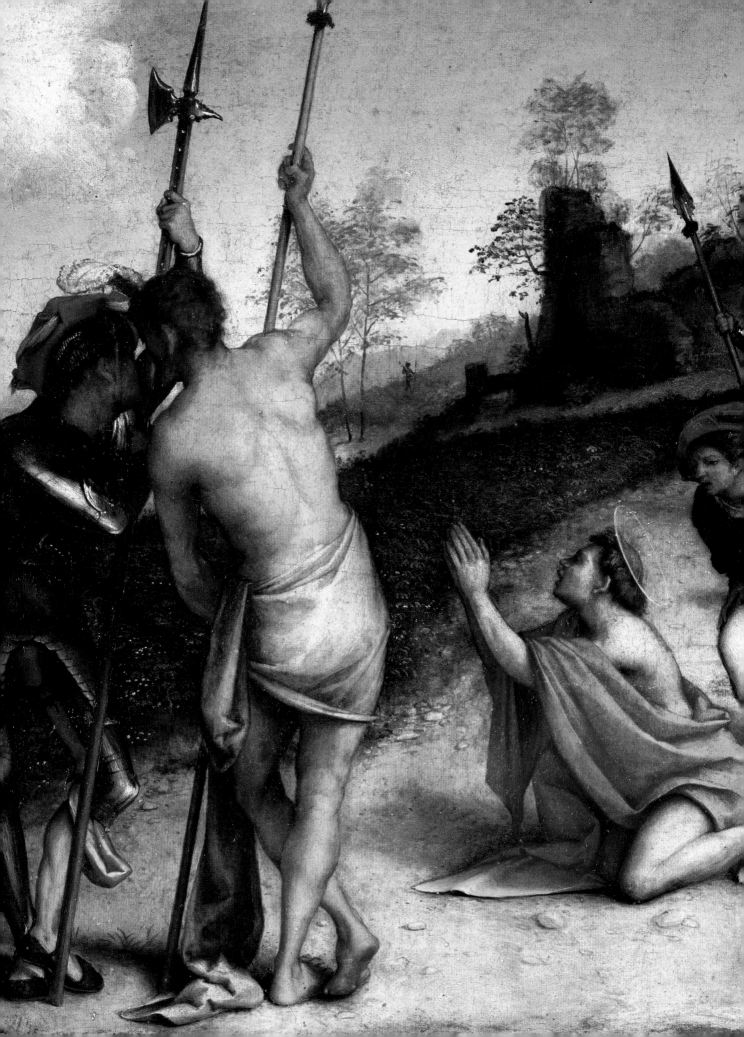

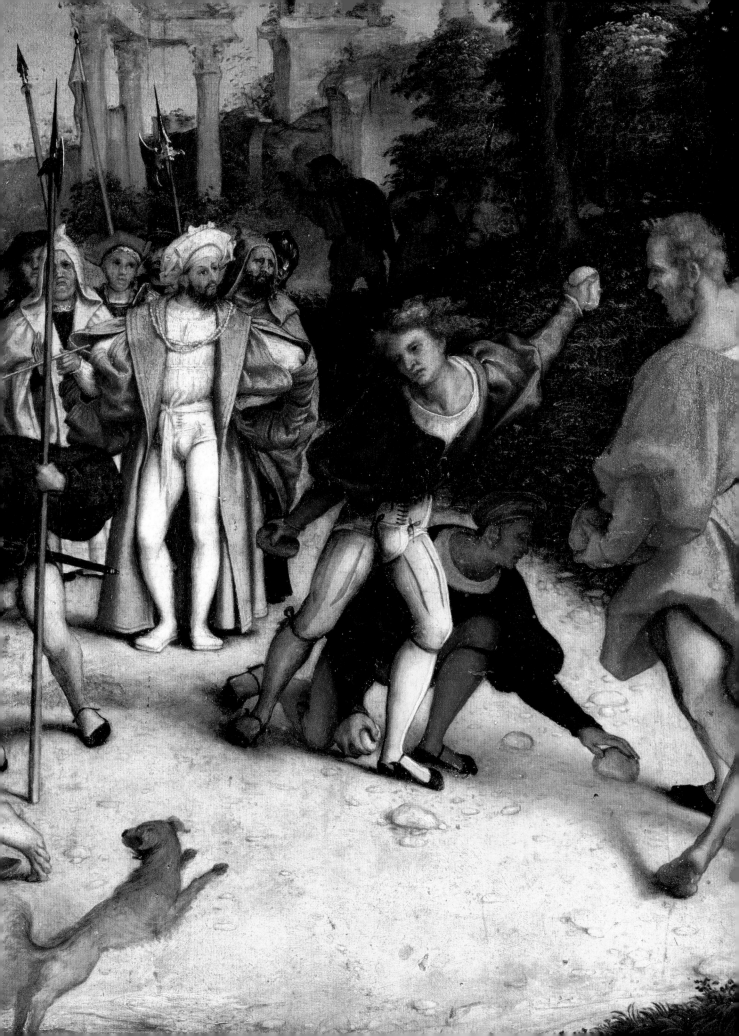

When questioned, Stephen recounted the sacred history and ended with words that would not have repudiated the Hebrew prophets of earlier centuries:

"You men who are stiff-necked and uncircumcised in heart and ears are always resisting the Holy Spirit; you are doing just as your fathers did. Which one of the prophets did your fathers not persecute? They killed those who had previously announced the coming of the Righteous One, whose betrayers and murderers you have now become" (Acts of the Apostles 7:51–52).

Of course, he meant Jesus.

Stephen's words were a clear provocation to the high priest and his deputies. "They began gnashing their teeth," according to the passage, and then took action, throwing themselves upon Stephen and expelling him from the city to a place where they began to stone him. They took justice into their own hands without a trial. A man named Saul, who would later become Paul, was present but did not take place in the slaughter; he held the others' garments in approval of their actions. As he was dying, Stephen cried out, "Lord, do not hold this sin against them!" (Acts of the Apostles 7:60). This scene reminds us of course of Christ on Calvary and of the persecutions that were to follow, many of which Paul led. To escape them, most of the early Christians had to flee Jerusalem.

The Christian community soon revered Stephen as a saint, especially since his "trial" and death so closely resembled Christ's. The story of Stephen's last days—his sermon, mishandling, and final prayer to God to pardon his assassins—closely parallels Christ's passion. In that era, the words "saint" and "martyr" were practically interchangeable. The Greek word for "witness" is *martys* or martyr. After Paul converted, he called Stephen, at whose stoning he had assisted, a "witness." Those who imitated Christ as far as their deaths were considered saints.

This "martyr clause," as it were, permeated the early centuries of Christianity, when persecutions were numerous. According to the Gospels, they began with Christ's birth. In the fifth century, the church declared saints those who—during their very short lives—did not have the opportunity to prove themselves. These were the "Holy Innocents," the children who were two years old or younger whom

pp. 64–65:
Lorenzo Lotto,
The Stoning of Saint Stephen,
1516.
Accademia Carrara, Bergamo.

Herod had slaughtered in and around Bethlehem after the wise men told him that a "king of the Jews"(and thus a rival) had been born there. The feast day of these children is December 28, soon after Christmas. Their death alone qualifies them as saints. "Innocent" became a given name, and from the fifth to the fifteenth century, thirteen popes bore this name. Only the first one was proclaimed a saint, but the reason for his sainthood is unclear. We do know that Innocent I proved to be an excellent diplomat when the "barbaric" Goths invaded Italy. He saw to it that the Church was centralized in Rome.

Stephen, who was declared "the first martyr" in the fourth century, is celebrated on December 26, which underscores his closeness to Christ. In Greek his name Stefanos means "crown"; its French form is Étienne, in German it is Stefan (or Steffen), and the English forms are Stephen, Steven, and Stevenson.

The Church venerates about forty saints who bear these names, notably the first king of Hungary, who spread Catholicism in his country and devoted his church to Mary. But there is also Saint Stephen Harding, born in Dorset, England, who was a monk at Sherborne Abbey before settling in France after a pilgrimage to Rome. In France he established the abbey of Cîteaux in the Côte d'Or region of Burgundy in the late ninth century. The abbey became the mother-house of the Cistercian order. Because of his interest in the Hebrew Bible, Stephen Harding boldly invited rabbis to explain difficult passages in the Old Testament to him.

In its early years, Christianity was a political as well as a religious problem, first in Palestine but later in all the nearby Mediterranean countries. Its tenets were opposed to the "civic religion" that reinforced the Pax Romana and venerated several gods who expected devotion and offerings. Christians who refused to do so were persecuted, but the punishment also served to make their religion known to others. As Tertullian, the first Christian writer in Latin, wrote in the second century, "The blood of the martyrs is seed." Persecution had been on the rise since the beginning of that century.

Around 117, Ignatius, bishop of Antioch, was wrenched from office and brought to Rome to be fed to wild beasts. But his journey to the capital of the empire, characterized by several long stays in cities along the way, resembled a proselytizing procession.

С Ігнатїй Бгоносцъ

Ignatius wrote seven letters, in which he described how he was treated:

I fight with beasts, both by land and sea, both by night and day, being
bound to ten leopards, I mean a band of soldiers, who, even when they
receive benefits, show themselves all the worse.

In his letter to the Trallians he wrote:

For I do indeed desire to suffer, but I know not if I be worthy to do so.

In a passage that clearly illustrates the importance of martyrdom, he begged
the Christians in Rome to do nothing to try and save him:

I shall willingly die for God. . . . I am the wheat of God, and let me be
ground by the teeth of the wild beasts, that I may be found the pure
bread of Christ. Rather entice the wild beasts, that they may become
my tomb, and may leave nothing of my body; so that when I have fallen
asleep [in death], I may be no trouble to any one. Then shall I truly be
a disciple of Christ, when the world shall not see so much as my body.

According to contemporary chronicles, the martyrdom of Saint Ignatius of
Antioch drew enormous crowds: although the number is probably exaggerated,
eighty thousand spectators flocked to the Colosseum. At least the bishop's martyrdom
was brief: two lions pounced and devoured him in a few minutes.

These semi-voluntary death marches would later be debated. Fortunately,
the Christians who were imprisoned and tortured for their beliefs were not all
thrown to the lions, even after publicly declaring their adherence to the new religion.
And although they survived, the new church still honored them. They were called
"confessors," and some were venerated as saints on their death.

As years went by, Christianity became more tolerated, even before the advent
of Constantine I in the fourth century. Although the emperor's life was not always
exemplary, the Edict of Milan—issued in 313 by Constantine (ruler of the western
regions of the Roman Empire) and Licinius I (ruler of the eastern parts)—put an end

Anonymous,
**The Martyrdom of
Saint Ignatius of Antioch**,
nineteenth century.
Rila Monastery.

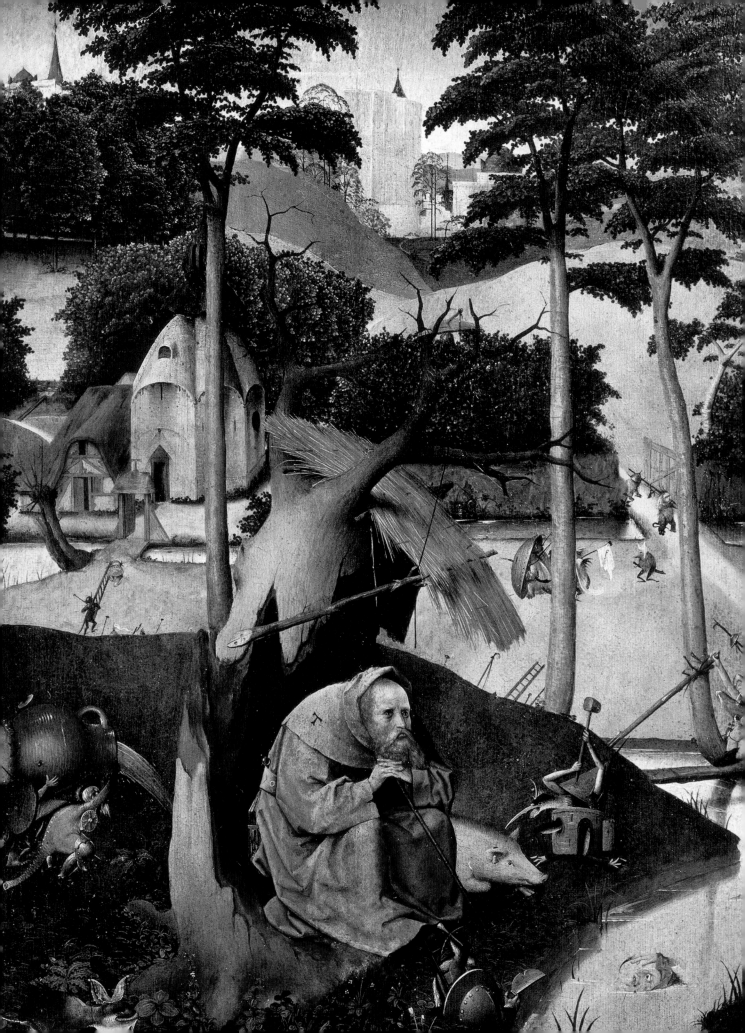

to the persecution of Christians. Many then sought martyrdom in abstinence rather than in death, depriving themselves of worldly pleasures and withdrawing into the solitary life of hermits. So "white martyrdom" gradually replaced the "red martyrs."

Consequently, we have Anthony, the first known monk or hermit, who went into the desert alone to divide his time between work, vigil, and prayer; a throng of disciples in the east imitated his exemplary life. Hundreds upon hundreds sought to enact Christ's words to the rich young man: "If you wish to be complete, go and sell your possessions and give to the poor" (Matthew 19:21). Like Anthony, they lived alone—the Greek work *monos*, meaning "single," explains the etymology of the word "monk." Among them there was one Athanasius of Alexandria, a theologian who accompanied his bishop to the Council of Nicaea in 325 and contributed to the formulation of the dogma of the incarnation of the Trinity. After becoming bishop himself and spending several years in Rome, he decided to live in the caves and tombs of the Egyptian desert. He took charge of public relations for monasticism and wrote his *Life of Saint Anthony* around 360, only a few years after the hermit's death. Athanasius did not stint on describing the saint's edifying adventures, as we read in a famous passage describing Anthony's temptation by the devil:

> [The devil] attacked the young man, disturbing him by night and harassing him by day, so that even the onlookers saw the struggle which was going on between them. The one would suggest foul thoughts and the other counter them with prayers: the one fire him with lush the other, as one who seemed to blush, fortify his body with faith, prayers, and fasting. And the devil, unhappy wight, one night even took upon him the shape of a woman and imitated all her acts simply to beguile Antony. But he, his mind filled with Christ and the nobility inspired by Him, and considering the spirituality of the soul, quenched the coal of the other's deceit. Again the enemy suggested the ease of pleasure. But he like a man filled with rage and grief turned his thoughts to the threatened fire and the gnawing worm, and setting these in array against his adversary, passed through the temptation unscathed.[1]

So he described the famous "temptation of Saint Anthony."

1. Athanasius, *Select Works and Letters*, Nicene and Post-Nicene Fathers, 2d ser., vol. 4, ed. Philip Schaff and Henry Wace (Edinburgh: T & T. Clark, 1885), 197.

Icon,
Saint Pachomius,
1779.
Private collection, Paris.

Ὁ ἅγιο ΠΑΧΩΜΙΟ

Battles against demons, which have struck the readers of Athanasius (as well as Bosch, Bruegel, and Gustave Flaubert) are a way of describing a spiritual confrontation that Arthur Rimbaud found "more brutal than any other battle," a way of participating in Christ's suffering, since He, too, was subjected to the temptation of power and idolatry in the desert.

Anthony was followed by Pachomius, a soldier converted to Christianity, who perfected the monastic model. The life of solitary monks could be dangerous, especially because of excessive asceticism and mortification. The former soldier thought it would be more suitable to bring monks together so that a superior could guide them toward moderation. Saint Syncletica, a Desert Mother from the fourth Century, said that obedience was the greatest virtue for those living in community because "obedience has within it the promise of humility." Pachomius invented the monastic model, at first only a group of huts around a place of worship surrounded by a cloister, and gave his first recruits a habit, a sleeveless tunic, a jacket trimmed with goat skin, and a hooded overcoat. Meanwhile Pachomius' sister, Mary, had created a convent for women near the Nile. Their number soon grew to almost four hundred, and these were the first nuns.

This movement quickly reached Western Europe, thanks not only to Athanasius' talent (a brilliant mind whose *Life of Saint Anthony* was often copied and imitated and enjoyed considerable success), but also because it was a healthy reaction—almost a question of spiritual survival—for the Church, which had fallen prey to politicization after Constantine, with its bishops becoming municipal bureaucrats, high-ranking officials, and financiers.

In the history of the Church, whenever its officers or members have become entangled in the nets of power, money, or appearance, a spiritual countermovement has arisen in response, to redirect the movement's flow. In its earliest days, the men of the Church who sought a life without compromise, who thirsted after the eternal, became monks.

In this context, what might be called "the Irish epic" is worthy of note. The new Church was established almost completely in the East and then in the Mediterranean world. But Pope Celestine I, a dynamic Christian who fought strongly against the many heresies of the time, was also concerned about converting Northern Europe

and establishing the Church in what was not yet called the British Isles. He first sent Palladius to Ireland, the "barbaric island," but he met with no success.

Most of the work of conversion was done in the mid-fifth century, thanks to a young Breton (at the time he would have been considered an Englishman or a Gaul) named Patrick, whose father was an official in the Roman Empire. One day Patrick was taken hostage by Irish pirates. Having escaped, he became a monk at the abbey of Lérins, near Cannes. Beneath the blue Mediterranean sky, he dreamt of the infinite variety of grey skies on the green island. "I can hear," he thought to himself, "the voices of the yet unborn calling me there."

Encouraged by Saint Germanus, the bishop of Auxerre (a married man who was elected by the people), Friar Patrick returned to Ireland to do battle with the Druids, convert the local inhabitants, and carve crosses on the menhirs. Once there, he could not appoint bishops to the towns, because there were no towns. So he consecrated bishops as abbots of monasteries, which were an ideal construct in his eyes. Ireland became a country of monks, dotted with monastery villages, some of which were almost the size of towns.

Monastic rule in Ireland was not to be taken lightly, and was influenced by Cassian, a man from the Balkans who had lived in Egypt and Lérins before founding an abbey in Marseille. Cassian used to praise the story of a novice who was obliged to water a rotten plank twice a day for a whole year so that the dampness would cause it to grow roots. After the trial failed, the plank was thrown away. But with this lesson, "the young man's faith in the virtue of submission grew daily."

Perhaps more wisely, the Church later adopted the rule of Saint Benedict, who founded the monastery of Monte Cassino in the sixth century. He was a moderate who proposed a program that was accessible to men of modest virtue with the motto: "The weak must not become discouraged." But the Irish were tempted to increase their physical and spiritual challenges, records in mortification. For instance, they practiced the crossfigill, an extended prayer with arms outstretched like a cross. Saint Kevin, who founded the abbey of Glandalough near Dublin, held the crossfigill for seven years, arms extended, and is believed never to have shut his eyes—day or night. He was supposedly so still that birds made their nests in his hands. More certain is that these monks practiced severe fasting, and only ate

one meal a day—never meat. Although it cannot be proven, an otter is supposed to have brought a large salmon to Kevin's abbey every day.

It would be wrong to suppose, however, that the monks who engaged in championing asceticism were uneducated. Jules Michelet's history related that Virgil, an Irishman who became bishop of Salzburg "was the first to affirm that the earth was round and had antipodes." The monasteries in Scotland and Ireland excelled in the study of all the sciences.

Virgil became bishop of Salzburg by taking part in a great mission throughout Europe that was launched by another important Irish saint, Columban, born around the mid-sixth century. Very young and handsome, he dreamed of becoming a monk at the time of the "pilgrimage for Christ." A group of Irish monks chartered a ship and set sail to convert the pagans. According to their chroniclers, some did not even take oars onto their ships but preferred to abandon themselves to God's will and bring His word to the place of His choice. We do not know where they landed. But, according to the medieval historian Jacques Le Goff, between the sixth and seventh centuries, Ireland "might have" exported one hundred fifteen saints to Germany, forty-five to France, thirty-six to Belgium, twenty-five to Scotland, and thirteen to Italy.

Many of the Irish missionaries proselytized in France and Brittany—for instance, Saint Corentin, who is supposed to have been the first bishop of Quimper; Saint Samson, the founder of Dol; Saint Malo; Saint Brieuc; Saint Tugdual; and Saint Winwaloe. Saint Gildas, the son of an English nobleman, was an exception: he studied in Gaul and became a monk in Ireland before returning to spread the Gospel in Brittany.

Fair Columban became a superman who could fell a tree with one stroke of the ax. He landed not far from Mont-Saint-Michel in the late sixth century, with twelve followers, the same number as the apostles. They crossed Gaul from west to east, preaching and converting, until they reached the Vosges Mountains, where they stopped, settling on the site of a small Gaulish village that had been burnt by Attila but was also a thermal spa, Luxeuil. The monks were content to establish their base near mineral springs with therapeutic value, creating sanatoriums there.

Cretan or Venetian School,
Saint Martin,
early sixteenth century.
Musée des Beaux-Arts
de la Ville de Paris, Paris.

Luxeuil was highly successful. Nobles and bishops flocked there, but were somewhat mistrustful of the strange-looking Irish monks with their thick white tunics and tonsure that crossed their heads from ear to ear, with long hair trailing down their backs. The kings were not saints: they did not trust the power that the Christian Church was gaining. Columban was at loggerheads with King Thierry II whose illegitimate children he refused to baptize; he also gave him his frank opinion of his ethics and crimes. The king decided not to kill him, merely banishing the saint instead. Columban went as far as Nantes and then turned around. His route took him to Paris, Meaux, along the Rhine, and as far as Lake Constance. Slightly farther south, one of his companions, Saint Gall, fell ill and stopped; later he founded another monastery there, near which a town sprang up. Columban forged on until his death in 615, after founding a final convent in Bobbio, Italy. He taught the practice of individual confession in every region where he converted the "coarse-mannered local people," who were somewhat "humanized" by the event. He also fostered a cultural renaissance wherever he went. And of course he instated several bishops. Well before Colomban's European "tour," it was possible to be a bishop and a monk at the same time.

Saint Martin, born in Pannonia (present-day Hungary) in the early fourth century, was one of those who carried out a dual role. The son of a tribune in the Roman army, he became a soldier, too (the name Martin is derived from the Latin *martinus*, meaning "devoted to the god Mars"). He traveled to Gaul. It is reported that, as a charitable gesture, he shared his cloak with a beggar in Amiens. The following night, he had a vision of Christ wearing in the same garment, which led to Martin's conversion and withdrawal from the Roman army. He lived as a hermit in Ligugé, near Poitiers. But then the bishop of Tours died. The congregation wanted Martin to succeed him and sent delegates to summon him. He balked but was ultimately persuaded. Martin was elected bishop of Tours—despite the opposition of some prelates who found, according to his biographer, Sulpicius Severus, that he had "a pitiful face, was badly clothed and ill-kempt." But he held fast to the monastic way of life. He went to live alone in a wooden hut on the other side of the river, but continued to take diligent care of his diocese.

Icon,
***Saint Simeon
on his Pillar***,
1637(?).
Georges Abou Adal
Collection, Geneva.

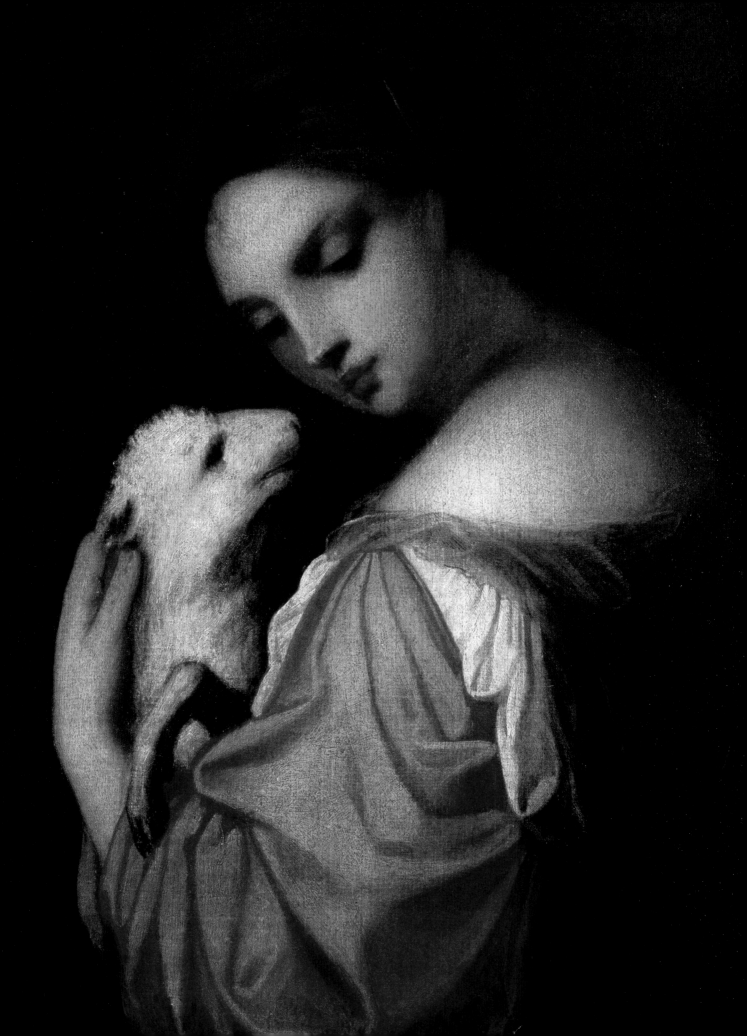

The desire to be a "white martyr" led other hermits to some strange behavior. Between the fourth and fifth centuries, Simeon retreated to the top of a towering column where the meager sustenance that kept him alive was hoisted to him on a rope. Young, acrobatic Eastern men imitated him, perching atop columns, porticoes, or dizzying heights, where they prayed to God and exhorted their many onlookers to sanctity. These aerial stylites (from the Greek *stylos*, "column") were more successful as curiosities than anything else.

Other religious fanatics crawled into holes in the earth and foraged on herbs and roots there; they were dubbed the "nibbling saints." In the fourth century, another extreme form of sainthood appeared in the Church of Alexandria and would later develop in Russia in the early centuries of the second millennium: participants feigned mental illness or derangement.

Simeon undertook other strange acts to hide his asceticism and conquer spiritual pride and any form of Pharisaism. Before climbing his pillar, he walked the streets of a town called Emesa with a dead dog found on a dung heap; he disrupted the clergy gathered in a church by throwing walnuts at the faithful, and he ate sausages on Good Friday. Similarly, the two children of a rich man of Antioch, Theophilus and Mary, disguised themselves as a mime and a prostitute and stationed themselves in a square in front of a church, "mocking the priests and passersby, for which they were beaten." But John of Ephesus, who narrates this tale, followed them to the ramparts of the city. "I saw them," he writes, "standing so that their faces were turned eastward, praying with arms outstretched like a cross; then they fell upon the earth, stood up, and fell again in prayer ... for a very long time."

The Byzantine Church canonized many of these clowns of the faith. "Christ's madmen," as they were called, were trying to avoid the sin of pride and not be admired for having renounced the simple pleasures of life. The easiest solution was to pretend to be insane, to become the Fools who denounced the true follies of the world. Their behavior earned them the derision of ordinary sinners, who mocked and despised them, but the "madmen" endured this abuse stoically and continued to criticize how far contemporary morals had departed from the Bible's teachings. Their charades of madness were not always successful; some of "God's madmen" came to be highly esteemed and were consulted by those in power. They were the inspiration for literary works by Dostoyevsky and Tolstoy. As icons

Padovanino,
Saint Agnes,
seventeenth century.
Galleria dell'Accademia, Venice.

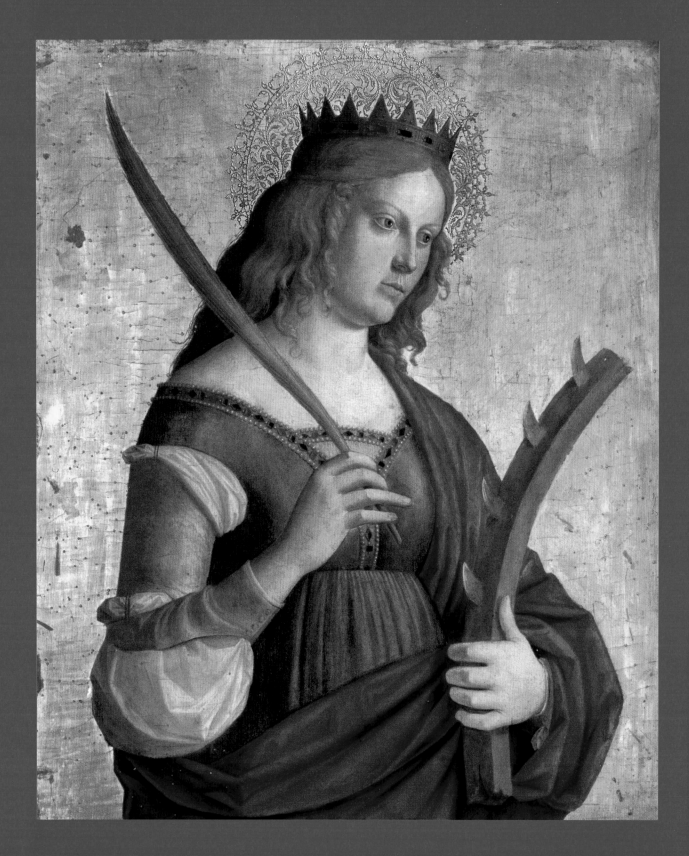

Giovanni Battista Cima da Conegliano,
Saint Catherine of Alexandria,
c. 1486–88.
Church of San Bartolomeo, Olera.

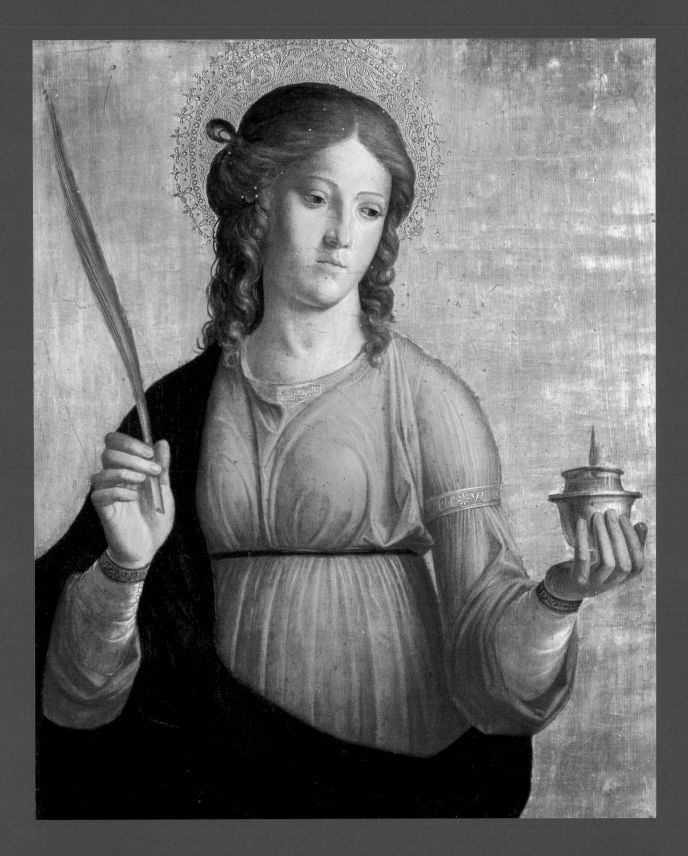

Giovanni Battista Cima da Conegliano,
Saint Lucy,
c.1486–88.
Church of San Bartolomeo, Olera.

they are represented naked and praying, with very long hair, and wearing a belt. However, these "crazy saints" were rarely imitated in the West.

From the fourth century on, churches and Church Fathers tried to marginalize such radical behavior. Saint Augustine, whose mother Monica was a Christian, was born in Tagaste (now Souk Ahras in Algeria). He crossed the Mediterranean after a rather dissipated youth and was converted by Ambrose, bishop of Milan, before becoming a great theologian. Augustine wrote that "the punishment does not make the martyr, but the cause does."

Virginity could also be a complicated and delicate question. Could it be understood as a form of asceticism, a voluntary martyrdom? Many of the hermits and monks definitely thought so. But what about the young women who were virgins?

Young Agnes (the feminine form of the Latin agnus or "lamb," the animal symbolizing purity in the Bible; in Spain she is called Inés), underwent both forms of martyrdom: she was physically martyred after being denounced to the prefect of Rome for refusing marriage in order to preserve her virginity. She was to be burned alive, but the fire would not stay lit. In the end, she was decapitated. Saint Ambrose himself (elected by the people as bishop of Milan, although he had not been baptized) relates Agnes's story in his book *De virginibus*.

Catherine of Alexandria shared a similar fate; her feast day is November 25. Virginity was not the issue, but she was brutally martyred by a machine constructed of spiked wheels and saws that turned backwards and pierced her body, because she dared to reproach the Roman emperor Maxentius for persecuting the Christians. Sermons by bishops on Agnes and Catherine exalt their martyrdom as virgins, without referring to their torture. Cecilia, a young Roman woman from a noble family in the third century, is likewise revered for her virginity rather than her physical martyrdom, although her biography, written centuries after her death, is far from clear. It refers to a marriage proposal that she declined, preferring to remain a virgin. In the same text, Cecilia persuades her betrothed, Valerianus, not to touch her, and she even converts him to Christianity. They both die as martyrs. The reason why she became the patron saint of musicians is unknown or disputed.

Among the many female martyrs who were virgins, we must not forget Saint Lucy, who lived and died in Syracuse, where an inscription bearing her name was

discovered in 1894. According to her legend, Lucy belonged to a rich family and wanted to give all their possessions to the poor. But her mother opposed the plan. There is no mention of a father or brothers. But when her fiancé saw his betrothed's generosity and realized that it threatened his hopes of a financially advantageous marriage, he broke off their engagement and furiously denounced her to the local authorities. A new type of martyrdom was invented for this young virgin: she was thrown into a house of prostitution. She valiantly resisted, but then it seems she was prepared to accept being raped. Lucy distinguished between the body and the soul: the body could be corrupted, even if the soul refused to be sullied. If her body was violated, her chastity was fortified. According to some historians, her fate served to justify prostitution in the Middle Ages. Her persecutors finally ran a sword through her throat. As a result, those suffering from sore throats and poor eyesight often visited her grave, since her name means "light."

In fact, in the late fourth century, a new cult of martyrs with healing powers arose. Visiting their graves, prayer, or worshiping them could heal certain maladies, depending on the circumstances of their lives or deaths, or personality. Some were viewed more as generalists, such as Emeterius and Chelidonius, who were martyred in an obscure corner of Spain. They would be forgotten today, if the Latin poet Prudentius had not written these lines at the time:

> Not in vain has been the pleading of the souls that here have prayed;
> Hence the suppliant turns with joy, as he dries his anxious tears,
> Knowing that his just petitions by the martyrs have been heard. [2]

The faithful had begun gathering at the tombs of martyrs. They collected their remains after the execution and placed them in catacombs or at the base of an old tree or in some other secret place. They worshiped there, and when the persecutions ended, they planted crosses or built small chapels. Some Christians had to struggle before getting permission to be buried near a saint's or a martyr's tomb: they hoped that in so doing, the saint would protect them when they came before "God's tribunal." This led to disputes over the bodies of saints, or presumed saints,

2. Prudentius, *Hymn in Honor of the Holy Martyrs Emeterius and Chelidonius of Calahorra*, from Sister M. Clement Eagan (trans.), *The Fathers of the Church: The Poems of Prudentius*, (Washington, D.C.: Catholic University of America Press, 1962).

or martyrs, and this practice lasted over centuries. The tale of the last rites of Saint Eligius, the Merovingian king Dagobert's bishop and minister, is worth retelling.

When Eligius died in Noyon around the year 660, Queen Bathild, who was regent, went there. She was a beautiful, strong Saxon woman, a former slave who, after being sold and resold, arrived in the kingdom of the Franks as a servant of the majordomo of the palace. One of King Dagobert's sons, who would succeed his father as Clovis II, noticed her and they were married. Clovis II, who was debauched, ribald, and a looter, made the right choice. Bathild was a great queen, and when the king died she was overcome with grief. She was also a good regent and a great Christian, retiring to a convent at Chelles as soon as her son Chlotar came of age at fifteen.

When Eligius died, she wanted to have his body brought to Chelles. Others wanted to bring his remains to Paris, but the inhabitants of Noyon were intent on keeping the saint near them. The queen settled the dispute with these words: "If it is either the saint's or God's will that he be taken where I want him to be laid, then let him be taken now; otherwise, we shall soon have the proof." Another future saint, Audoin, continues the tale: "After these words, when they approached the coffin to lift it, it was so heavy that it was impossible to move it." The queen herself "tried with all her strength, but had no more success than if she had tried to move a mountain." She then concluded that the saint preferred to stay in Noyon.

What ensued provides the key to the mystery. When it had been unanimously decided that the body would be interred in the town, they tried once again to lift the coffin, still according to the future Saint Audoin, "which had become so light that two men could carry it easily.... Upon seeing the miracle, the inhabitants of Noyon offered thanks to the Lord."

The narrator does not give us the queen's reaction. But there was a similar incident at Arras, not far from Noyon. The bishop there, Saint Vaast, had died a century earlier. The holy man wanted to be buried in a wooden chapel on the bank of a small river outside the town. But when the porters were ready to leave, they could not budge the body, which had become so heavy. The archpriest of Arras quickly acknowledged the miracle and, according to a contemporary text, asked the dead saint to give an order "that he be taken to the place that we [the clergy] have long prepared for you." Suddenly, the porters were able to move the

body with no effort into the church, where it was buried on the right side of the altar. Their intent is clear: the clergy of the cathedral wanted to keep the saint there not only the better to worship him, but also because he brought prestige to that sacred place and would continue to provide many more material advantages.

Not only were the saints' bodies coveted, but also their clothes, and even the instruments of torture used to persecute them. Then there were the bones: separated from the body or having been in contact with it, these relics were placed in transportable reliquaries made of gold or else gilded. Goldsmiths became rich, as did simpler blacksmiths in villages, who showed some talent for working with fine metals. At the time of the first crusades, the search for relics of Jesus or the apostles—bits of the cross or other artifacts—became an obsession. The relics business became a growing concern from the eastern to the western Mediterranean—whether they were genuine or not, for who could really tell?

The search and veneration of relics ignited a heated debate among the Church Fathers. Some opposed their worship, emphasizing that adoration should obviously be reserved for God alone. Others insisted that since the martyrs' bodies were holy, so were the objects that they had touched. Some stressed the didactic benefit of such veneration: the faithful were edified by the sight of the relics and became more interested in the saints' lives. From the year 410 onward, a council convened at Carthage decreed that all commemorative monuments to saints were to be destroyed unless they contained relics or had been built in a place that was sanctified either by the martyr's life or death. Finally, in 767, the Council of Nicaea decreed that any altar used to celebrate the mass must contain a stone that held a saint's relics. Even today, canon law 1237 underscores that "an ancient tradition that must be preserved insists that the relics of martyrs or other saints be placed beneath a stationary altar." This does not apply to mobile altars, the ones transported by military chaplains, for instance.

In article 1190, the code of canon law emphasizes that "the sale of holy relics is forbidden," adding that "remarkable relics or those that are the object of great veneration may not be removed or definitively transferred without the permission" of the Vatican. This stipulation also applies to "images that are the object of special worship," which allows for a certain latitude of evaluation.

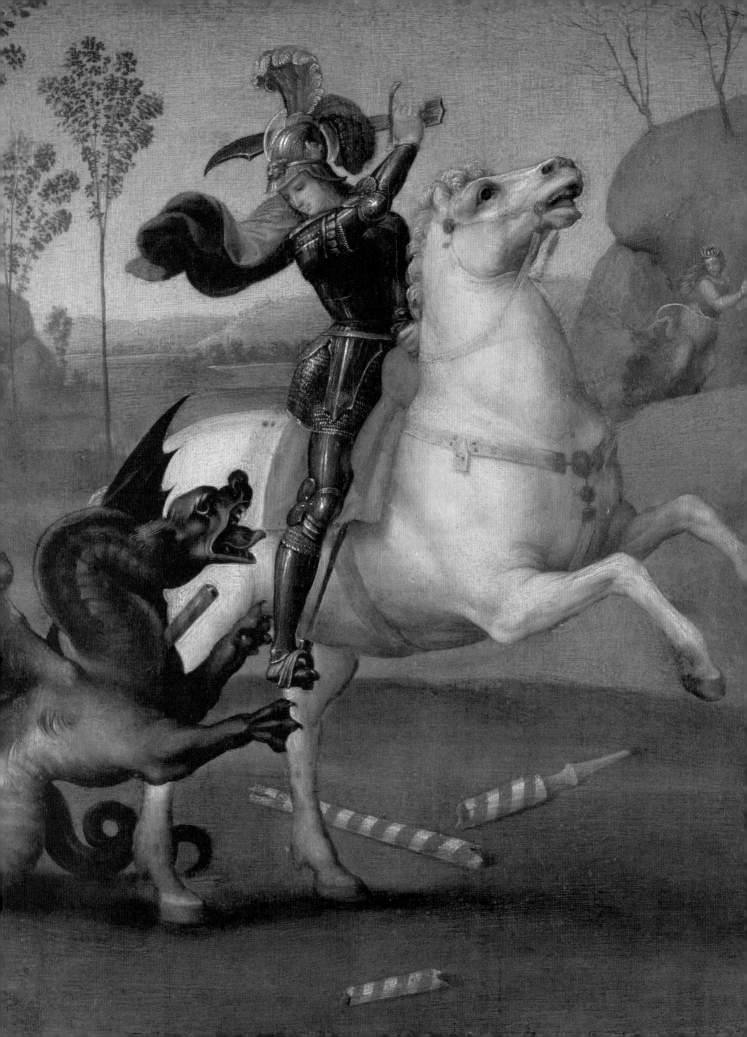

From Martyrs
to Doctors
of the Church

Enough was enough. As more of Western Europe was converted, the cult of the martyrs and their relics expanded, to the point where it became an embarrassment to the ecclesiastical authorities.

Consequently, in the fourth and fifth centuries, two types of churches were built in Syria: next to the basilicas of the bishops, *martyria*, or martyrs' churches, were constructed, recognizable because of their dome. Beneath that, in the middle of the church, was an altar dedicated to the saint whose relics had been collected there. The congregation that gathered around the altar sang hymns to honor the saint, and worship lasted into the night. The faithful were waiting for miracles and occasionally planned banquets there. The bishops were unsuccessfully opposed to them. In 692 a council forbade these ceremonies and the preparation of food at the altar.

In Gaul, Saint Martin had to oppose the worship of a pseudo-martyr to whom the bishops (his predecessors or neighbors?) had erected an altar near Tours. These regions scarcely had any martyrs. One exception in Lyon is well known. Eusebius, the fourth-century author of an *Ecclesiastical History*, specifies that forty-eight martyrs died around 177, including Pothinus, the bishop of the city, who was brought

Raphael,
**Saint George and
the Dragon** (detail),
c. 1505.
Musée du Louvre, Paris.

before the tribunal on a stretcher where the public was allowed to stone him, and Blandine, a very young slave girl, whom the beasts apparently refused to devour and who was then "flagellated, dismembered, burned over low flames, before being put into a net and given to a bull who threw her into the air like a toy." She was finally killed with a broadsword.

The local Christians enlisted the new bishop of Lyon, Saint Irenaeus, a wise theologian, to bring news of the event to Pope Eleutherius, a Greek who had become the twelfth successor of Saint Peter in Rome.

In the second half of the fifth century, a text was circulated in Toulouse relating the martyrdom of Saint Saturninus, who was the first bishop of the town. A crowd supposedly brought him to the Capitol, a temple dedicated to Jupiter, where a sacrifice had been prepared. The saint's feet were attached to a bull about to be burnt as sacrifice. The pagan name of Saturninus was gradually transformed into French as Saint Sernin.

Precisely because so few relics of local martyrs had been found in Gaul, many such pieces were brought from the east from the fifth century onward. In Rouen a clerk named Victritius described the arrival of several relics into the city: "Now a large part of the celestial host deigns to visit our city, so that we must live with a crowd of saints." According to Victritius, these saints would increase good deeds, since in the east they had provided "cures for the unfortunate." Relics were not only brought into the Christian world but also stolen, passed from one monastery to another. Since fragments of bones or pieces of cloth that had touched the saint possessed an almost magical power, their worship could be profitable.

It often happened that villages where a person of extraordinary piety had died began to cultivate their worship and even attribute miracles to them. In this case, they were considered saints. This fervor and the ensuing cults, and even the trafficking that resulted from them, all contributed to the spread of Christianity. Tombs of saints, or those considered saints, became centers of the religious life in the region. Families or clerics often built monuments or small buildings around the tomb in cemeteries located outside the city walls. These places became so important that they became "cities beyond cities." As Saint Jerome (a convert who became an ascetic and was the secretary of Pope Damasus, who encouraged him

Sebastiano del Piombo,
***The Martyrdom of Saint Agatha**,*
1520.
Palatine Gallery, Palazzo Pitti, Florence.

to translate the gospels into Latin) wrote that, by venerating the saints, "the city changed its address."

The cult of the saint became so successful that it became important to monitor it and prevent abuses. Rules began to be established here and there with no judicial framework. Several elements could contribute to the official recognition of a male or female saint: their reputation among the people, accounts that extolled their virtues, or their miracles. But in the middle of the first millennium, there were no serious investigations that preceded the recognition of sainthood.

The creation of the first calendars provided a structure for this ebullience of sanctity. The major feast days were of course connected to Christ's memory. Around the year 500, Christmas was celebrated on December 25, Epiphany on January 6, Easter on the Sunday following the spring full moon, the Ascension forty days later, followed by Pentecost, ten days later. In other words, just like today. Gradually the celebration of other important saints, beginning with Peter and Paul, became interspersed among these major feast days. Locally, the bishops consolidated their powers by creating lists of martyrs and assigning dates when the faithful were called to venerate these saints individually.

Before adding a name to the lists, the bishops requested a report on the candidate's life, virtues, martyrdom (if applicable) and death, his or her miracles, and occasionally as much direct testimony as possible. These were often not serious inquests, and many of the reports are quite similar. The bishops themselves began to write narratives called *Passions*, which often reworked the texts of sermons given at the anniversary masses for a saint's death.

These texts were liberally sprinkled with fantastical or sadly spectacular references. One of the *Passions* related that Saint Agatha, a young Sicilian woman whom the governor of Catania denounced as a Christian after she spurned his advances, had her breasts cut off and was then placed over a red-hot brazier. But a violent earthquake saved her from death. The frightened governor ordered the torture to be stopped, and Agatha died in prison. Because of the dual phases of her martyrdom, she became the patron saint of nurses and has often been invoked to heal pain caused by fire.

One of the fifth-century *Passions* tells us about Saint Lawrence. There is documented evidence that in the middle of the third century there was a new wave of violent persecutions in the Roman Empire. As a result, Pope Sixtus II, who was elected a year earlier, was executed in 258. Meeting him on the road to his martyrdom, Lawrence wanted to join him. But the pope insisted instead that he sell the Church's possessions and distribute the profit among the poor. This was because the main goal of the persecutions ordered at that time was to seize the holdings of the young Church. Fearing that Lawrence would enact the pope's wish and thus deprive him of his booty, the emperor immediately summoned Lawrence, who came to the palace with a cohort of poor people and told him: "Here are the eternal riches that will never lose their value." Lawrence was then tortured different ways, one of which is scantily documented: he was laid out on a type of grill over a bed of fire, and when he was consumed by the flames, he supposedly said to the emperor: "One side is done, now turn me over and eat!" The cult of Saint Lawrence spread rapidly. In Rome thirty-six churches bear his name. In sixteenth-century Spain he was considered as a compatriot, and Philip II had a palace built in the shape of a grill in homage to Lawrence.

Bartolo di Fredi,
**The Martyrdom
of Saint Lawrence**,
before 1410.
Pinacoteca Nazionale, Siena.

Another *Passion* tells the story of Saint George, who came back to life after being put to death in Palestine around the year 300. He was originally from Cappadocia, part of the present-day Turkey, where Christianity was widespread at the time; according to some versions, he was martyred in the late fourth century. This legend (or others, since it is difficult to separate the facts in the history of so many Georges) says that he arrived one day in a town where young children were sacrificed every year at random to a fearsome dragon. That year fate had chosen the king's only daughter, since many of the young inhabitants of the town had already been devoured. As the girl was marching to meet the dragon, she met George, who promised to kill the dragon if the king and his people would convert. He succeeded in killing the beast, and the town became Christian.

Another text attributes to Saint Ambrose, bishop of Milan, a highly complicated tale according to which, during Diocletian's reign, a prefect called Dacian had persecuted thousands of the faithful, when George arrived and threw off his armor before donning Christian garb and proclaiming his faith. He was then tortured in various ways but miraculously survived, until the day when he was beheaded. But the prefect Dacian and all his ministers were punished by the wrath of God.

George became better known later, at the time of the Crusades, thanks to Richard I (the Lion-Heart) and the English kings. He was highly venerated in England and often represented wearing a breastplate and armor as a contemporary knight. He became their patron and then the patron saint of the entire country. Much later, in 1222, the Council of Oxford proclaimed his feast day, and there is a chapel dedicated to him in Windsor Castle.

Well before the Middle Ages, local churches usually had their own calendars. But Rome, of course, was concerned about harmonizing religious celebrations and veneration. A document sent from Italy to Lyon, and then to Auxerre in the late sixth century lists the names of all known saints in the east and west.

The reports sent to the bishops requesting the recognition of a saint sometimes produced a new literary form, the *Vitae* (or *Lives*) of saints. Some chronicles had already been written, notably by Gregory of Tours, Saint Martin's successor as the spiritual leader of the city, who was a saint himself, and the author of a richly

Russian icon,
Saint George,
fourteenth century.
The Russian Museum,
Saint Petersburg.

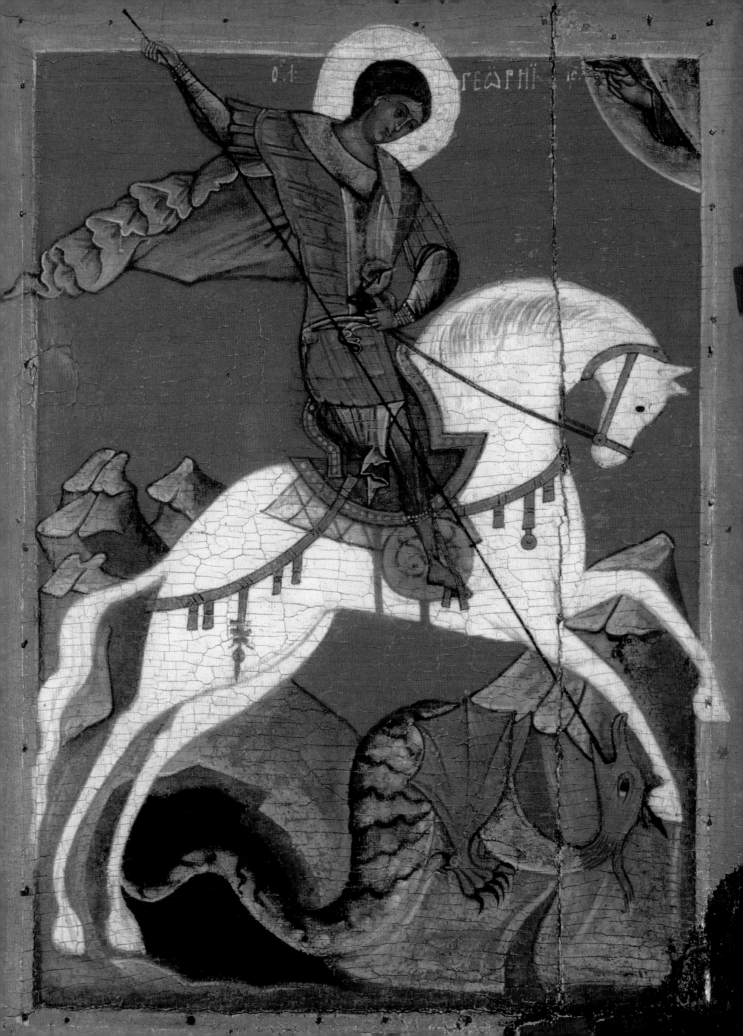

detailed *History of the Franks*. As soon as a bishop died, a request was often made that a document praising him be created. For instance, Saint Audoin, Saint Eligius' friend, related the major events of his life.

Thanks to these *Lives*, which were sometimes closer to historical fact, we are more familiar with the life of Saint Genevieve, the patron saint of Paris. Its author, who died in 502, was a priest who did not know the saint; he praises this "servant of God," who took care of the sick and acted as the spiritual leader of the clergy and the people of the city. Born of Christian parents in Nanterre around 420, Genevieve met Germanus, the bishop of Auxerre, as a child, when he assisted her upon her arrival in Paris at age fifteen, where she was consecrated to God as a virgin by Bishop Vilicus. When, in 451, Attila and his Huns had galloped across Europe

on their small horses and stood before Paris, the confident and elegant woman comforted the frightened inhabitants. She did well, and a coalition of other "barbarians" and Romans forced Attila and his men to turn around.

The people of Paris attributed to Genevieve what they considered to be a miracle. Years later, Paris was besieged again. The saint saved the inhabitants of her city from famine by going to get wheat by boat (the Franks had cut off all provisions by land) and sailing back up the Seine. After her death, her veneration was first cultivated by King Clovis and his wife Clotilde.

Clovis was a "barbarian" as well, but also a Frank. Unlike most of the others, these barbarians did not subscribe to Arianism, which was a heresy to Christians: the Arians denied Christ's divinity since he was created by God the Father. In 481, Clovis, aged fifteen, ascended the throne. He already had a reputation as a good fighter. Seeing the Goths, Franks, and other tribes moving into their lands, the bishops who were witnesses to the decline of the Roman Empire thought that Clovis might be a heaven-sent leader.

Rémi, the bishop of Reims and a member of the Gallo-Roman aristocracy, offered Clovis an alliance of sorts. For his part, Clovis, who wanted to expand his kingdom and govern peaceably, saw the value of an alliance with the Church and the elite who were partly Christian. So an unwritten alliance of Church and State became stronger and stronger. To consolidate it, a wife who was also a daughter of the Church was found for the Frankish king: Clotilde was a Burgundian princess who lived in Geneva. It is an easily forgotten fact that Clovis already had a son, Theoderic by another marriage; he was probably illegitimate.

Avitus, the bishop of Vienne on the Rhone, another Gallic aristocrat, celebrated the marriage. Since he, too, had contributed to protecting Gaul from the Arian heresy, the Church also made him a saint, as well as Clotilde. After Clovis' death, she led a quiet life, but it was marred with family strife.

An ecclesiastical tendency was beginning to emerge that signified a trend on the bishops' part to sanctify the princes or their consorts who protected them. This happened in Britain to Saint Audrey, whose first name was Aethelthryth. This princess had married Prince Tonbert, who died three years after their marriage. She was betrothed to a new husband, Egfrid, who was no more than a child.

Pierre Puvis de Chavannes,
***Saint Genevieve Bringing
Supplies to the City of Paris
after the Siege*** (detail),
1898.
Musée d'Orsay, Paris.

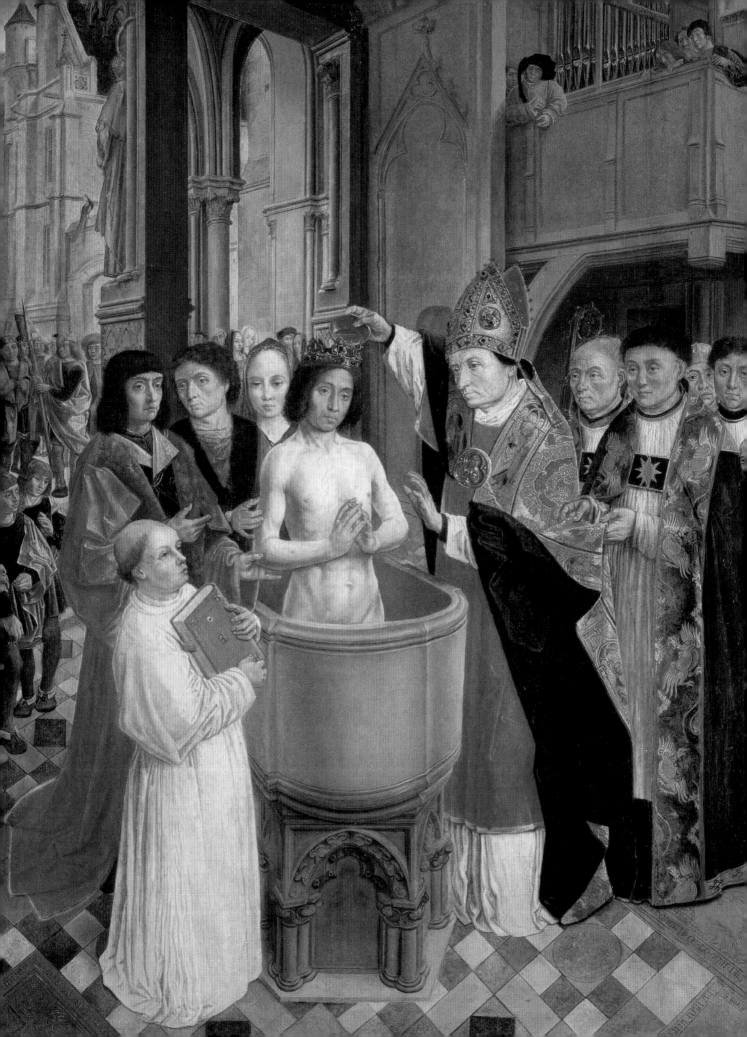

When he was old enough to become her husband, she refused to live with him as his wife and retreated to a convent, where she led a very ascetic life. Bishop Wilfrid, who had been appointed at York but went to Paris to be consecrated only to find his seat had been taken upon his return, approved of Aethelthryth's behavior. Throughout his many hardships, Wilfrid showed great devotion to the Roman pope, although the English Church appeared to be leaning more and more toward autonomy. Wilfrid was also made a saint.

The history of Radegund, the wife of King Chlotar I, Clovis' son, bears at least one similarity to Audrey's life. She, too, renounced her husband and the world, but for another reason: after the king assassinated her brother, Clovis' succession was violently disputed, and Gaul was divided into four kingdoms. Radegund was first received as a deaconess in Noyon, entrusted with religious and humanitarian responsibilities. She then went to Tours, where she established a monastery for men, and later established a convent in Poitiers, with funds she received from her cruel husband in a moment of weakness when he feared the fires of hell. This convent was not remarkable for its austerity—there were even gaming tables for the residents. Radegund, a strong-willed woman who led the bishops by the nose, was also an epicure. Bishop Venantius Fortunatus, who was also a poet, savored with delight the tasty dishes that the abbess of the monastery of Sainte-Croix in Poitiers prepared for him:

> The bounty of today's supper was prime,
> at your table vegetables drizzled in honey
> ran twice up and down the board,
> the smell alone could have fattened me....
> Then a haughty mound of meat appeared,
> a mountain—with adjoining hills,
> fish and ragout girding them,
> a little garden for supper within.[1]

The cult of the gourmet saint did not go far, however.

1. Venantius Fortunatus, *Poems to Friends*, trans. Joseph Pucci (Indianapolis: Hackett Publishing Company, Inc., 2010), 95–96.

The Master of Saint Gilles,
The Baptism of Clovis,
c. 1500.
National Gallery of Art, Washington, D.C.

These different narratives have several meanings. First of all, unlike Radegund, the men of those times were at odds with nature, which they felt was hostile to them: life on earth was merely a passage through a vale of tears. They did not know where to turn their prayers and invocations to seek comfort in such an unfriendly world. The animal that symbolized the hostility of this world and the malevolence of nature was undoubtedly the dragon. He appears in the early centuries as a representation of the devil or the forces of nature, although, in the latter case, it could be disciplined and exploited.

Great bishops and saints were able to kill dragons or make them men's allies. Saint George, Saint Martin, Saint Athanasius, the Irish monks, and many others tamed or vanquished dragons. Venantius Fortunatus relates that Marcel, who became a bishop despite his humble origins, freed his fellow inhabitants in Paris from a dragon: "As Marcel began to pray, the dragon lowered his head and begged his pardon, wagging his tail." This dragon was not the Devil (who, of course, never asks for forgiveness) but represented nature, which could be tamed.

It was also a matter of demonstrating to these people who were burdened with superstitions that the God of Jesus Christ was the only true God, and so the best and most powerful. The missionaries' strategy was based on this principle. Fair Saint Columban, but also Saint Amand (or Amandus), a Merovingian, who evangelized in the north of what would become France and Belgium, and Boniface, English born, who preached in the eighth century in what would become Germany. These were three giants, who shook the sacred trees dedicated to other gods, beseeching these gods to punish them if they truly existed.

A tacit complicity or else a clear agreement linked the saints, who were almost all bishops then, and the civic authorities—princes, kings, and chiefs—who were attempting to govern the decaying Roman Empire. Childebert I (c. 496–558), Clovis' son, ordered by edict that all statues and monuments dedicated to demons be destroyed:

> All those who do not immediately remove from their land the statues
> and idols erected to demons there, or those who prevent the bishops
> from destroying them will be fined.

In exchange the bishops made the petty nobles and their consorts saints, or promised to preserve them from eternal damnation. The belief in purgatory was introduced only in the twelfth century. The royal edicts outlawing idols were not well observed, so the Catholic missionaries and other religious chiefs found themselves confronting one another face to face: "your God against mine."

However, the problem for Christians was that their God, by taking a human form, had also acquired human frailty; their Savior was a suffering and persecuted Christ. The Resurrection displayed his power, of course, but after that many of the first Christians had been martyrs. So instead of a direct conflict with the other religions, Christians adopted a more subtle approach. They changed their preaching style and drew on aspects of folklore, using relics of all sorts. Clovis II, Dagobert's son, venerated Saint Denis, the first bishop of Paris, who had died a martyr in around 250, so Clovis went in person to the abbey where the saint was buried and coolly removed an arm from the body so that he would always have it near him. This caused a scandal but also sent a message: in their dealings with the "barbarians," some bishops tolerated or took responsibility for practices that were far removed from Christian sermonizing and spirituality. Furthermore, the passage of the Irish monks had left a deep impression: the most religious members of the medieval aristocracy preferred to orient themselves toward monasteries rather than set their sights on episcopal functions. Their families preferred to support the monasteries financially. The time when the bishops practically single-handedly faced off against the presence of the "barbarians" was receding, and a power struggle was forming among the aristocratic families. Some bishops took sides and thereby lost some of their prestige as well as their possessions. Charles Martel, the iron man of Gaul in the mid-eighth century, secured the allegiance of his partisans without ruining himself by distributing church lands to them—the land in the region surrounding Lyon was divided among six Bavarian counts. His two sons, Pepin the Short and Carloman, shared his kingdom after his death; they were pious but also political-minded and decided to put the Church in order so as to consolidate their power. The more pious brother, Carloman (who retired to a monastery), made an appeal to Boniface: what was good for Gaul would also be good for Rome, since the capital also wanted to preserve order, especially among the saints.

Boniface was in the vanguard of the movement for European unity. In 716 he left the Benedictine abbey of Nursling (Southampton) and set sail for France. He represented a church that was closely tied to Rome, where the Anglo-Saxon kings often went on pilgrimage. In Gaul he convened councils that prepared the union of throne and altar symbolized by Charlemagne. He would also reconvert Roman Germania. He established monasteries, consecrated bishops, and increased the number of schools with the help of monks and nuns from Britain, especially his cousin, who had lived for seven years in the Holy Land, who is honored today in Germany as Saint Willibald. Having converted Bavaria in particular, Boniface left on a mission to Frisia, north of present-day Holland, and sailed down the Rhone. Shortly after arriving, he and his companions were massacred. His body was returned to Germany where Boniface is still honored.

Of course Rome closely followed the progress of this "new apostle," as he was called. Just as Boniface distinguished between good and bad bishops, true and false saints as he traveled, Rome's intent was to make it clear that the saints were not substitutes for the gods. The practice of making sacrifices to the saints in Saxony, for instance, in the same places where sacrifices to the gods had been made, had to be eliminated. Similarly, in the region around Soissons, a certain Aldebert—very much alive—was considered a saint by the local population, and had to be put in check. The people believed he had been made bishop by a letter from Christ that fell from the sky. Aldebert was going about distributing his own relics—locks of hair, bits of fingernails, and so on.

A few innovations in the period demonstrate the Romans' willingness to organize the cult of the saints. First of all, they instituted the holy day of All Saints' Day. At the beginning of the fourth century in Rome, Pope Boniface IV transformed the Pantheon, the temple that the Romans had dedicated to all the gods, into the church of Saint Mary of the Martyrs. Their goal was to ensure that each and every saint, including the ones who were ignored or little known, would be worshiped. Set on November 1, All Saints' Day would be linked in the eleventh century with the remembrance on the following day, November 2, of all the faithful who had died. Over the centuries the two celebrations have become almost interchangeable in many cultures.

Icon,
Vladimir, Boris, and Gleb (detail),
sixteenth century.
The State Tretyakov Gallery, Moscow.

Another important measure was taken in 789, when it was forbidden to worship any saint whose martyrdom could not be proved and whose virtues were not reasonably known. At the same time, monks were encouraged to rewrite the saints' lives in Latin so that they could be used throughout Western Europe. This did not prevent the good monks from including a few extra miracles in these *vitae*, which always had a great effect on the masses.

The litanies of the saints were recited at Saint Peter's in Rome, which presupposes that there was a list. The hierarchy of the saints was gradually set, and Mary was their queen. This made sense, since the Council of Ephesus had proclaimed her Theotokos, mother of God.

In 847 the archbishop of Mayence divided the other saints into four categories: apostles, martyrs, "confessors of the faith" (who proved their faith in different ways when their lives were in danger, although they were not actually martyred), and finally "virgins," who were not always female, but for those who were it was the preferred route to sainthood.

The relics business, however, was still flourishing, and kings who had converted were soon recognized as saints. Vladimir, king of Dalmatia, was beaten by the czar of Bulgaria, who wanted to seize his small kingdom and threw him into a prison near his palace. The czar's daughter, the young Cossara, was a good Christian who, true to the teachings of the gospel, came to wash the prisoner's feet and visited Vladimir often. She was taken with him and got her father's permission to marry him. The czar gave Dalmatia to the newlyweds, who lived happily for years thereafter. Unfortunately, when the czar died, an adventurer killed his son and successor and tried to seize Dalmatia. The cowardly traitor invited Vladimir to his court but had him assassinated as he was leaving the palace chapel. Vladimir is highly venerated in the Balkans.

In the tenth century, Wenceslas, duke of Bohemia, ascended the throne at age eighteen. His father was a Christian, but his mother was not. As regent for five years, she banished priests, persecuted the faithful, and even young Wenceslas, who was forced to hear mass at night. All this changed when he became duke. He had many churches built, recalled exiled priests, and was considered a model ruler. But his ambitious brother took their mother's side and had his brother killed

Wenceslas II, King of Bohemia,
in the *Codex Manesse,*
1300.
University Library, Heidelberg.

in the square in front of the church as he was going to mass. Wenceslas was martyred at age twenty-three and made a saint; he is venerated as protector of the Czechs.

In other countries, a king who converted was immediately considered as a new saint. Olaf of Norway was one such: at age fourteen, he joined a group of "Normans" who descended from the North Sea on their longships to plunder the bordering countries. During one of these expeditions, he was somehow baptized. King of Norway at twenty-one, he instituted Christianity as the state religion. Although he was cruel and immoral, he was made a saint. He died in a battle against partisans of the old religion, was considered a martyr, and remained the patron saint of his country.

The English kings and nobles in that period who often assisted Rome in organizing the Church were of course also made saints. Edmund, the leader of a small kingdom on the great island, was taken prisoner by the Danes, who at the time were seizing Christian souls. Then there was Edward the Confessor, who ruled and was beloved by his people before William of Normandy conquered the country, as well as Edgar, who ruled peaceably around the year 1000, who was a saint because he was king.

In Germany, Henry, duke of Bavaria, was crowned leader of the Holy Roman Empire by the pope in 1014, giving him control of Germany, Austria, Switzerland, Northern Italy, and the present Netherlands. He was betrothed to Cunegonde of Luxemburg and had a tumultuous reign. One of the countless legends that sprang up has it that—because she wanted to preserve her virginity—Cunegonde persuaded Henry to live with her in complete abstinence, which he accepted. They were both canonized, and Henry, who was extremely devoted to Rome, also tried to reform the papacy—not such a simple task.

It was easier for a Catholic sovereign to be proclaimed a saint than an ordinary Christian. Rome's decision to take the cult of the saints in hand was certainly beneficial to contemporary monarchs but, as we shall see, the clerics profited even more.

Anonymous,
Saint Edmund Martyr,
Saint Edward the Confessor,
and Saint John the Baptist
(detail from the *Wilton Diptych*),
c. 1395–99.
National Gallery, London.

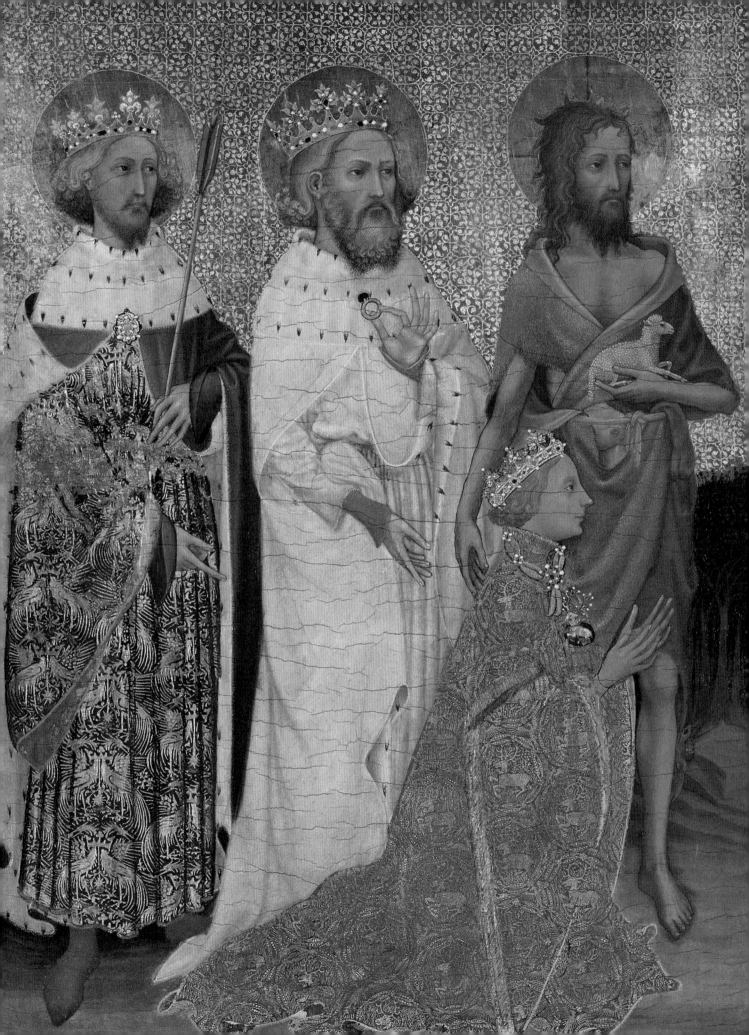

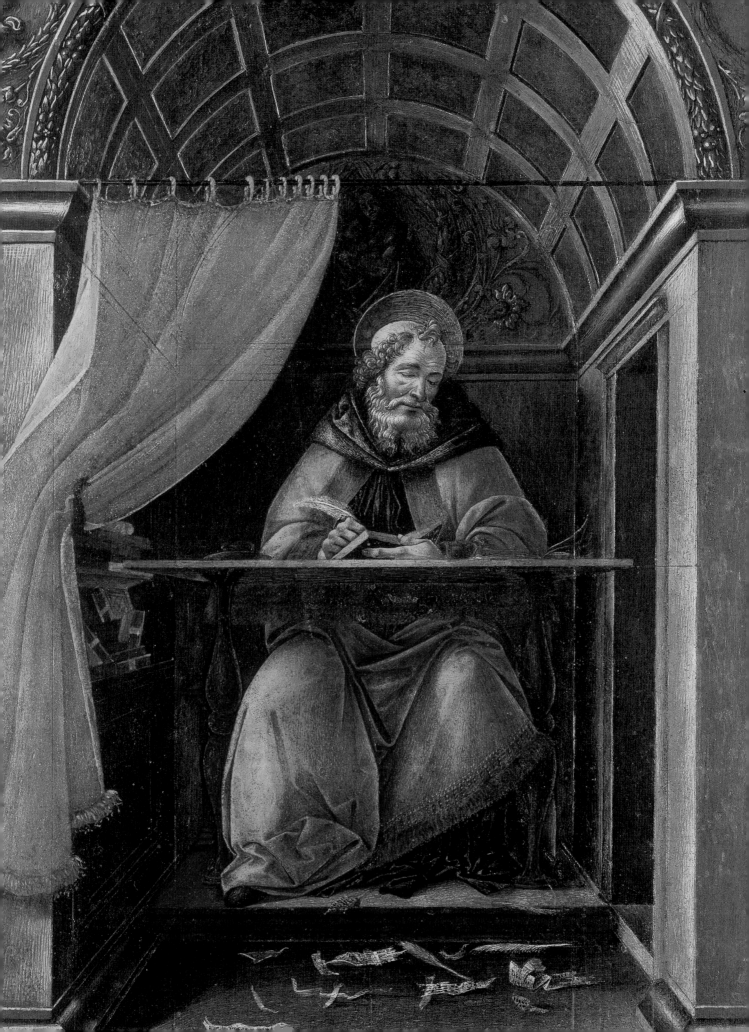

Kings
and Laymen

Bishop Hugh of Grenoble (aka Hugh of Châteauneuf) was influential in Rome; Hugh had left his episcopal appointment, discouraged by the immorality of the local clergy. But an order from the pope, who had consecrated him, sent Hugh back to his diocese after a sabbatical year. Hugh had a wide range of connections and did many favors. One of his professors in Reims, a nobleman from Cologne named Bruno, was looking for an almost inaccessible place where he could found a new religious order whose members would live in solitude and only come together at mass. Bishop Hugh suggested the mountain range of the Grande Chartreuse to Bruno, and so the Carthusian Order was born.

Hugh had a finger in many pies. He was interested in the designation of saints and the renewal of monastic life. Toward the end of the first millennium, many monasteries had been struck with what was called the "feudal malady": they had fallen under the sway of lords who were less burdened by spiritual preoccupations than by the desire to increase their possessions and power. But in 910 a monastery was established in Cluny, Burgundy, whose order became of vital importance, because it was directly dependent on the Holy See and no other entity. Cluny belonged to the Benedictine Order, and there was nothing like it at the time.

Sandro Botticelli,
Saint Augustine in his Cell,
c. 1495.
Galleria degli Uffizi, Florence.

The monks of Cluny, including Hugh, were trying to restore order in a feudal society in Western Europe, where bold and ambitious lords were burning and pillaging. They were attempting to install a new, much more rigorous politics of sanctity. They began by consecrating their own founders, Berno and Odo, as saints. Odo has been somewhat forgotten today, but he was an ironhanded man of the Touraine who was instrumental in the decision that Cluny would depend solely on Rome. It is said that he also wrote a life of Saint Gerald of Aurillac: a weakling in his youth, he became—after his father's death—a great lord, who was pious, intelligent, and freed many of his serfs. Gerald was a lay saint and a model to other feudal lords who could only think of feasting, debauchery, and riches.

Since the seventh century, monks in the Eastern Church had reserved the authority to appoint saints. Now the monks of Cluny decided to take the matter into their own hands, too, since intellectuals and their clergy were also in favor of reestablishing order among the saints. Some appointments were more dubious than others, with some miracles possibly due to subterfuge, or other devilry.

The first step toward reform was taken when Ulrich of Augsburg died. Ulrich had been a page and then a monk who established two monasteries, one in Switzerland and the other in the Black Forest. Consecrated bishop of Augsburg in the year 923, his brothers in Cluny, led by Hugh, wanted to have the pope declare Bishop Ulrich a saint.

Although he is somewhat forgotten, Ulrich seems to be the first saint designated by the papacy. This pope was John XV, an Italian, the son of a priest, who had turned to the Germanic world to escape the influence of the Roman aristocracy. This no doubt partly explains his recognition of Ulrich's sainthood. During John XV's papacy, others were declared saints without Rome's approval, whether they merited the title or not. Nonetheless, a process began with Pope John and Ulrich that would gradually confer recognition of saints exclusively to the papacy, considerably strengthening the pope's authority over the church.

Almost at the same time in the East, the patriarch—or spiritual leader of the Greek Church—was responsible for the recognition of sainthood. Consequently, at the end of the first millennium, the notion became prevalent in episcopal circles east and west that no dead person could be canonized without the authorization of a central power.

Francisco de Zurbarán,
**Saint Hugh of Grenoble
in the Refectory of Chartreuse**,
1633.
Museo de Bellas Artes, Seville.

Canonization: the word "canon" comes from the Greek *kanon*, meaning "rule" or "norm." It is often used in the Catholic Church, when referring to the "canon" of the mass, for instance, the "rule" that must be followed in celebrating the Eucharist. "To canonize" a saint means to inscribe his or her name in the official list.

The canonization of a person has become a significant event, especially since the saint is upheld as an example to the universal Church, not only to the Christians in a particular region, town, or even village. Canonization also went hand-in-hand with a "clericalization" of the saints that is noticeable in the early centuries of the second millennium. Until then the cult of the saints had been a privilege of kings and queens, princes and princesses; it would now be extended as the almost exclusive province of clerics, and other men and women of the church.

Of course there will always be exceptions, just as there had been bishops, monks, and nuns who were recognized as saints before the change of direction in canonization. As we have seen, the very first saints were Jesus' companions and their disciples, or else Church Fathers in the early centuries like Augustine, whose theological influence was and remains considerable, or a figure like Ephraim of Syria, another theologian, who wrote a commentary on the entire Bible. He was an excellent priest whose sermons were delivered in verse; Ephraim also created the hymns that began the practice of liturgical chant. Other early Church Fathers were Saint Benedict, "the patriarch of Western monks," and the great converters like Patrick and Augustine of Canterbury, a somewhat unusual case. He was prior of a monastery in Rome when Pope Gregory the Great sent him to convert the Anglo-Saxons in Britain, where Christianity had declined after the Saxon invasions, around 600 CE.

Leading a group of about forty monks, Augustine reached the great island somewhat daunted, but succeeded in converting King Aethelberht of Kent and established a monastery near Canterbury. He died there and is considered the founder of the English Church. His is a special case because it was not until 1850 that the English episcopate requested that his feast day be registered on the calendar of the Catholic church.

Although centralization was justified and indispensable, it did slow down the process of sanctification at times. For instance, Nicholas of Flüe, born in 1417

Andrea Delitio,
Saint Augustine (detail),
c. 1477–81.
Choir loft of the cathedral
of Santa Maria Assunta, Atri.

in the canton of Unterwalden in Switzerland, became the patron saint of his country, but was not canonized until 1947 by Pope Pius XII. True enough, he was not a clerk but a father and a farmer, considered a wise man in his community. In 1468, when he was over fifty, he had a vision while tending his flock, and left his wife—with her consent—to become a hermit in the mountains. His reputation as a saint soon spread, although he never belonged to a religious order. A cell was built for him near a small chapel where a priest came to give him Communion. Nicholas died when he was seventy years old.

The other Saint Nicholas, who was bishop of Myra in Asia Minor in the fourth century, is better known to us, although his popularity only began in the eleventh century. He died in Myra, where he was worshiped for a time. But the locals abandoned his relics when they fled in fear of a Turkish invasion. He was forgotten until 1087, when pirates from Bari in Southern Italy found his relics. His cult began to develop, especially in Germanic countries and Russia, where he is the patron saint. There are many legends about Nicholas, but the best known is the tale of the resurrection of three small children whom a butcher had killed and put in his salting tub. When an angel told Nicholas of this crime, he revived the children and punished the culprit.

How did this Saint Nicholas become Father Christmas? He was long considered the protector of small children in northern European countries and, on his feast day, December 6, children there received candy or toys. When the Dutch and then others emigrated to North America, they kept this custom, while the local inhabitants of English origin who also lived there gave presents to their children on Christmas Day. Little by little the two celebrations overlapped, and with the help of the Protestant Reformation, which did not recognize saints, the white-bearded Nicholas became Father Christmas. After a famous soft-drinks maker launched a publicity campaign in the 1930s with Nicholas in red, the color was forever associated with him.

One of the first famous incidences of Rome's intervention in the cult of the saints concerns a rather forgotten archbishop of Canterbury called Alphegus. Not long after the year 1000, Danish pirates kidnapped him and held him for a sizable ransom. Alphegus told the people, who loved him dearly, not to give in to the Danes' chicanery. One day, when they were drunk, the Danes killed Alphegus.

In this sense, he may be considered a martyr. At the time his canonization was taken for granted. One of the archbishops of Canterbury who succeeded Alphegus was an Italian named Lanfranc. After much deliberation, he concluded that Alphegus was murdered more for political than religious reasons. He consulted with Anselm, an English monk, who was a great theologian of the time. Could the Holy See validate the cult of Alphegus if he was not killed because he refused to deny Jesus Christ? Anselm replied that John the Baptist, who had been considered a saint for centuries, was not beheaded because he denied Christ but because he had criticized Herodias' morals. With this, the Italian Archbishop of Canterbury was persuaded.

This same Anselm succeeded Lanfranc years later in Canterbury. At the age of twenty, after a quarrel with his father, a despotic widower, Anselm went to France and divided his time between study and "pleasure seeking," as his biographers modestly put it. The study proved to be more profitable, since he became one of the great philosophers of his period. Meanwhile he had entered the abbey of Bec-Hellouin where he took many courses before becoming its abbot. In this position he had many significant relationships with contemporary figures, from William the Conqueror, the Norman who became king of Britain, to popes Gregory VII and Urban II, who both wanted to "breathe the perfume of his virtues" and "enjoy a little of his affection." He became archbishop of Canterbury and primate of Britain. He used the lengthy stays he was required to make in Rome to his advantage by reintroducing the calendar of English saints that the Normans, deeming it too "rusticated," had retracted.

Many saints in this period were also archbishops of Canterbury, starting with Thomas Becket, whose death inspired the Nobel Prize winner T. S. Eliot's play *Murder in the Cathedral* (1948). Thomas Becket was chancellor to Henry II, Plantagenet king of England, who also controlled a good part of Western France. When he was forty-four he was ordained a priest one Saturday during Pentecost in 1162, and consecrated as archbishop the following day in the cathedral where he would die. He was a great aristocrat who did not dislike luxury and opulence. Defending the rights of the Church of England, which had become very divided, he soon began quarreling with his friend the king. To escape the king's judgment, he was forced to flee to France, disguising himself as a lay brother with a long

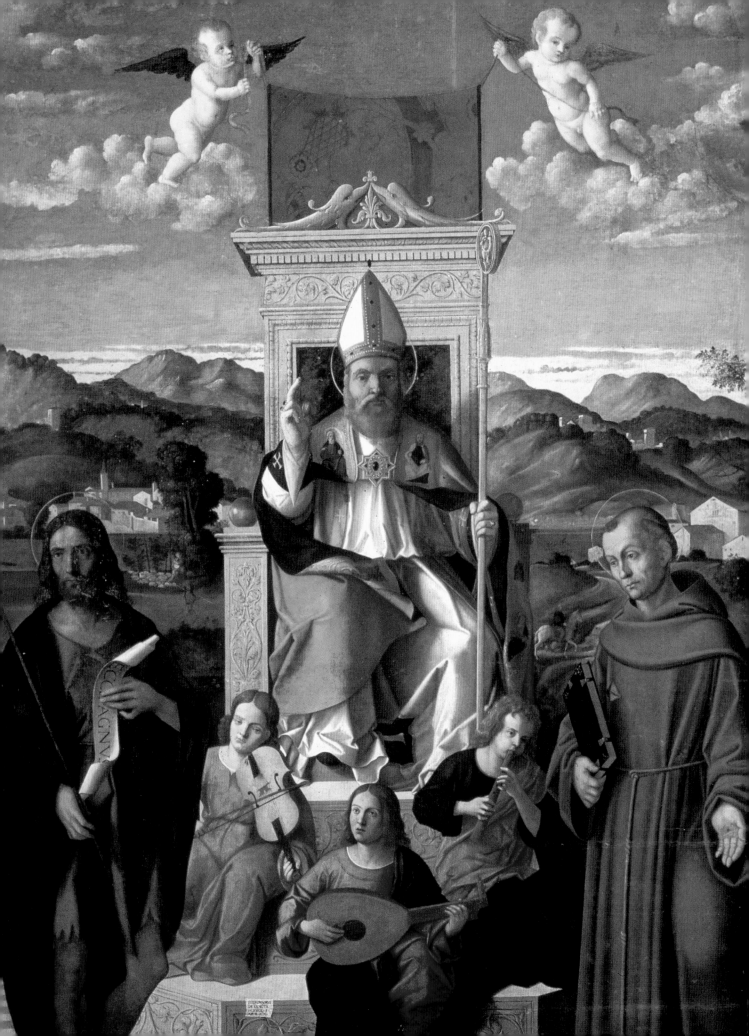

beard and an old tunic. But he remained combative, launching excommunications against British dignitaries from the abbey of Pontigny, while the king threatened retaliation against the Cistercian monks of Britain. As a result, Becket was forced to seek refuge among the Benedictine monks in Sens.

Despite the ever-present danger (some bishops and many of the nobles were supporting the king), Becket decided to return to England, where he continued the struggle in defense of religious rights. He had the people's support, but the king had had enough. Four weeks after his return, four knights entered the cathedral. Becket bravely fought them off in vain. Mortally wounded, he prayed with his dying breath, "I am ready to die for my Lord, that in my blood the Church may obtain liberty and peace."

Thomas Becket was swiftly canonized three years later. In the sixteenth century, when King Henry VIII broke with Rome and proclaimed himself head of the Church of England, he had Becket "decanonized."

Even before Becket's canonization, Rome had asserted its power in Pope Urban II's refusal to recognize the sainthood of an abbot whose monks affirmed that he had worked miracles, although he could offer no witnesses. Pope Alexander IV had forbidden the popular Swedish cult of King Eric, who was assassinated one evening during a drunken brawl. He also decreed that no one, regardless of his or her saintly reputation, could be the object of a cult without Rome's permission (which did not stop some bishops from assuming they had it). Innocent III's papacy marked an important step. Elected pope when he was thirty-seven, a great theologian and biblical expert with knowledge of the law, Innocent declared himself "Christ's vicar" and not Peter's, like all his predecessors. He also affirmed his *plenitudo potestatis*, full pontifical power over all churches and ecclesiastics, tempered of course by morality and canonical rules. He reformed the Roman Curia and gradually introduced the infrastructures of a true "pontifical State." During his reign, however, relations with the Eastern Christians deteriorated.

Of course, even absolute pontifical power cannot remain indifferent to the cult of saints. Gregory IX, Innocent's successor and emulator, published decretals, letters like legal briefs that confirmed the Roman pontiff's absolute judicial power in all cases having to do with saints throughout the church. This was a pivotal event.

Girolamo da Santacroce,
**Saint Thomas Becket in His Glory
Surrounded by Musical Angels, Saint John
the Baptist, and Saint Francis** (detail),
1520.
Church of San Silvestro, Venice.

From then on, canonization comprised three stages: first, a local investigation ordered by the bishop or superior of the convent; then papal investigators were sent to collect testimony; and finally, the dossier in favor of the new saint was examined.

Some began to question the pope's infallibility, however, when he rejected one proposal or accepted another. Thomas Aquinas replied that canonization reflected "the divine Providence that guides the Church." If mistakes were made, no doubt as the result of false testimony, canonization was still necessary for the good of mankind.

The same pope, Gregory IX, made saints of two famous women in the Germanic world, Hildegard of Bingen and Elizabeth of Hungary. Hildegard, who was born in Hesse and became abbess of her own convent, had many visions prefiguring the Apocalypse; she also wrote tracts on theology, medicine, anatomy, and astrology. "The Sybil of the Rhine" also corresponded with the great men of her time. But her canonization process was hindered by a problem with miracles.

For her part, Elizabeth, the daughter of the king of Hungary, had married the Duke of Thuringia when he was twenty, and she fourteen. They were a very devoted couple. But the duke, Louis IV, soon died on a crusade and Elizabeth's mother-in-law, who hated her, ordered her out of the ducal palace. Elizabeth established a hospital and is said to have displayed a contented and unshakable faith. She died at twenty-four, after becoming a devotee of Saint Francis's teachings.

The great founders of religious orders, Francis of Assisi and Dominic, were active at the same time. Francis was born while his father was traveling on business in France; his mother named him Giovanni, but when his father returned, he insisted that the boy be called Francesco. A custom of the time held that a child born in the father's absence was named after the people of the country where the father had been. An opposing legend has it that Francis received this name because, even as a young boy, he spoke French perfectly, which may also be true. What is certain is that after a tumultuous youth and a turn as a soldier, Francis discovered the light and the teachings of the Gospels. "Of all men, after Jesus," wrote French author Ernest Renan in his *Studies in Religious History*, "he possessed the clearest conscience, the most perfect simplicity, the strongest sense of his filial relation to the Heavenly Father.... His life is a ... perpetual intoxication of divine love."[1] Having enlisted a few friends, he got papal approval for his group of followers. Soon his

1. Ernest Renan, *Studies in Religious History* (London: Richard Bentley and Son, 1886), 306.

Bartolomé Estéban Murillo,
Saint Elizabeth of Hungary Caring for the Lepers (detail),
1671.
Hospital de La Caridad, Seville.

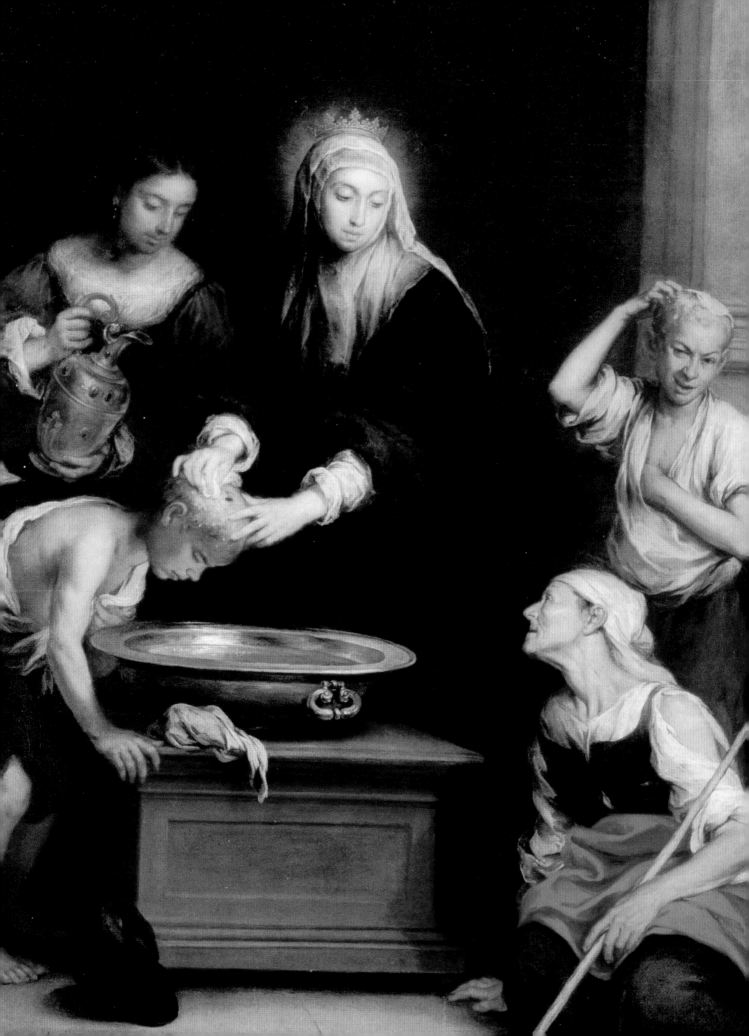

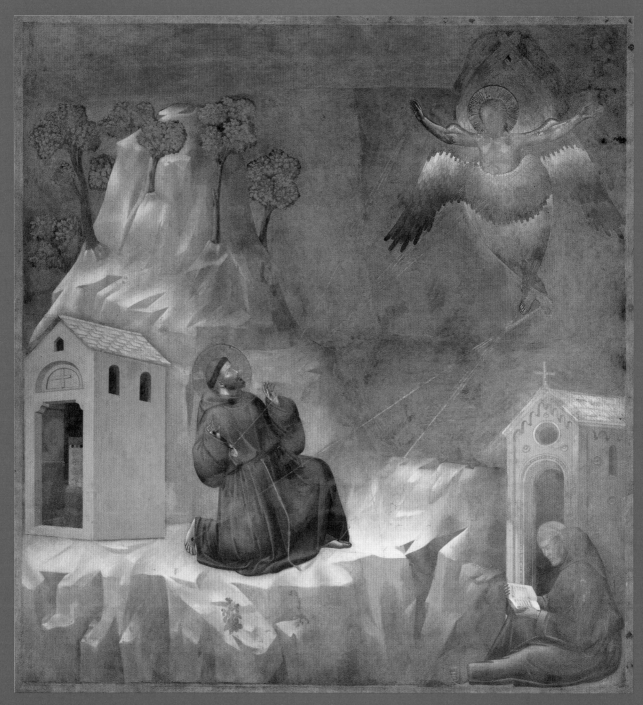

Above:
Giotto di Bondone,
**Saint Francis Receiving
the Stigmata** (detail),
c.1295–1300.
Upper Church, Basilica of Saint Francis
of Assisi, Assisi.

Facing page:
Fra Angelico,
**Christ Surrounded by Symbols
of the Passion with the Virgin Mary
and Saint Dominic** (detail),
c.1439–45.
Convent of San Marco, Florence.

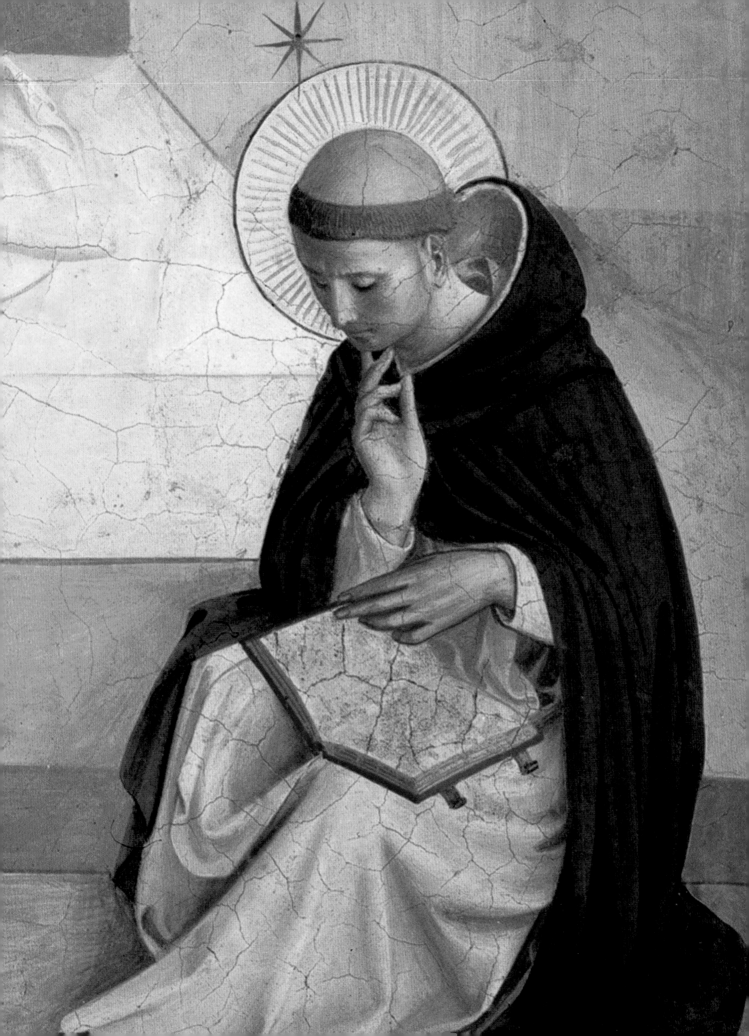

"brothers" were preaching throughout Italy and had many followers of their own. So many that the "fraternity" had to be divided into "provinces," each with its own rule approved by Pope Honorius II. The Franciscan Order was born and its founder could withdraw to the mountains, into his beloved nature, and write the "Canticle of the Creatures."

Many of the Francises who followed were canonized: Francis of Paola—who established subgroups within the Order of Minims (or "least of all," because they craved poverty)—was called to King Louis XI's bedside because the king was so afraid to die after leading such a "complex" life that he wanted to be spiritually prepared by a holy man.

The Savoyard Francis of Sales did not found a religious order but inspired Jeanne-Françoise de Chantal, a Burgundian widow who was one of his penitents, to found the Order of the Visitandines, to care for the weak and the infirm. When she died, there were eighty-six Visitandine convents in France.

Dominic was born in the province of Burgos, Spain, in 1170. He had traveled throughout almost all of Europe and was dreaming of visiting the Carpathian Mountains and the Black Sea when the pope advised him to go and combat the heresies in the South of France. Pontifical legates were already operating there, but they were ineffective, living in a grand style and great luxury. Dominic and his companion Diego of Acabo, who would soon die, decided to go and preach throughout the towns there, recruiting followers as they went. In 1215 Dominic set up a foundation in Toulouse in the Eastern style: it would be absolutely poor and own no property. The vocation of these "preaching brothers" was recognized and approved by the pope: these monks, unlike many other pious members of the Church at the time, would be educated, with a gift for sermonizing, teaching, and debate. The order soon flourished in Paris, Bologna, Madrid, Segovia, and Limoges. By 1221, during a chapter meeting of the order in Bologna, Dominic—finally exhausted from his labors—died.

He was canonized seven years later. Francis of Assisi was sanctified only two years after his death. Clare, his religious sister, was the same. Touched by her spiritual brother's teachings at fifteen, she decided to follow him, and later established the Order of the Poor Clares, modeled after the Franciscans; they were

Peter Paul Rubens,
The Miracle of Saint Ignatius of Loyola,
c. 1617–18.
Kunsthistorisches Museum, Vienna.

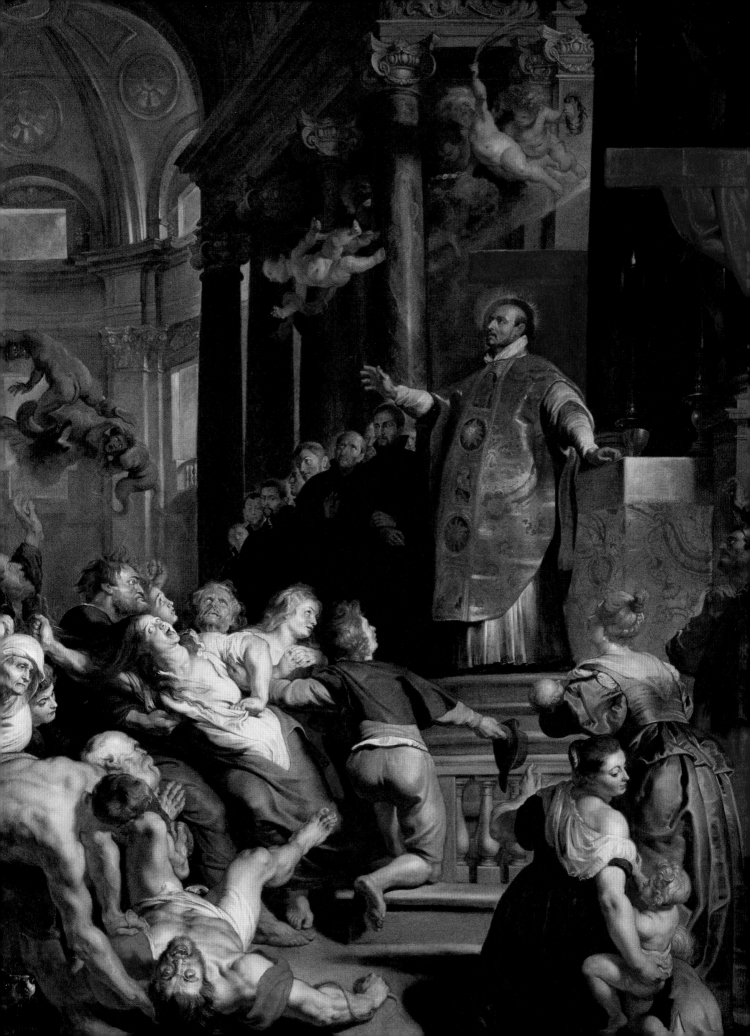

later called the Clarisses. The careful investigation of the miracles attributed to her, required before canonization, was completed in less than six days.

But it was not that easy for everyone. Francis and Dominic, and a few others, like Ignatius of Loyola in the sixteenth century, frequented the popes, who knew them well. But many priests, monks, and nuns—and even more laypeople—had never set foot in Rome, nor in the capitals of their own countries. Even if the local people or their clergy praised their spirituality, and a holy and generous life, requests for canonization were delayed at length at best, or else ignored, especially since these requests were frequent.

There were also cases when founders of an order were eclipsed by one of their monks. Robert of Molesme, founder the Cistercian Order, was soon cast into the shadow of Bernard of Clairvaux. This monk was always in the vanguard, spending eight years traveling from sovereign to sovereign in Europe to block an antipope, before composing the rule of the Order of the Templars. He struggled against the Cathar heresy and abuses at the court in Rome, and preached the Second Crusade. As the cofounder of the Cistercians in a sense, Bernard's canonization was swifter than Robert's, which was originally rejected. Similarly, Rome also ordered that the inquest on Gilbert, who established a mixed order of men and women in Britain in 1148, be reopened. These men and women lived in separate monasteries and created small communities that included an orphanage and a leper house. Gilbert endured many trials before dying a blind man when he was one hundred years old.

During Pope John XXII's pontificate in the thirteenth century, canonizations became even scarcer. John XXII was French, elected at the time when Peter's successors resided in Avignon; he had completed brilliant legal studies in Montpellier. He had an uneasy papacy, because the Church was divided, and he wanted to restore order. The popes in Avignon, who had different temperaments and political mind-sets, were united at least around the question of canonizations, which became strict legal proceedings, with the pope represented during the "trial" (which could last for months) by a "promoter of the faith," better known as the "devil's advocate," who played the role of public minister. Moreover, before inquests and trials began, the Holy See demanded letters of recommendation not only from the bishops, but also from "kings, princes, and other prominent and upstanding persons."

These recommendations, however, were not always enough to convince the powers-that-be in Rome. The history of the canonization of Louis IX of France, better known as Saint Louis, offers an unfortunate example. If there was ever a king whose sanctity was without question, it was certainly Louis.

In those days there was a congenial intimacy between the Church and royal power. Becoming king aged twenty-one, Louis led an almost monastic life, although not celibate: hearing mass three times a day during Lent, praying often, going on retreats to the abbey of Royaumont, creating hospices and hospitals, receiving the poor at his table, and making every effort to make all facets of his politics conform to the Gospels. But he was not unconditionally submissive to the papacy. At times he opposed the interventions of the papacy in the affairs of the State and the Church of France. Nor was he indifferent to the criticism of "clericalism" from the nobility and the new bourgeoisie; he made a great effort to be discreet when he wore the robes of a penitent. He participated in two crusades and died in Tunis in 1270 during the second one, about twenty days after his son, who had accompanied him, during an outbreak of typhus.

He should have quickly been recognized as a saint. Furthermore, on the road, as his body was being returned to France, miracles were attributed to him in Sicily and Northern Italy. His reputation had already sanctified him, and the great religious orders he was intimate with were also favorable. But the wait lasted twenty-seven years, although the year after his death, the new pope, Gregory X, requested a favorable report from his Dominican confessor. It was soon delivered in fifty-two highly favorable chapters. But the pope, who was caught up in a council and other concerns, let the case drag on and died without resolving it in 1276. Gregory had three successors in less than eighteen months. Another pope, Martin IV, reopened the procedure in 1281 and began a new inquest into the miracles attributed to Louis IX, his life, and morals. The Roman offices began to examine the results, dragging their heels as usual, when this pope died. His successors occupied the papal throne only for a short time. One of them, Celestine V, who was elected under complicated circumstances, resigned after five months—the only time this has occurred in papal history—and retired to his hermitage.

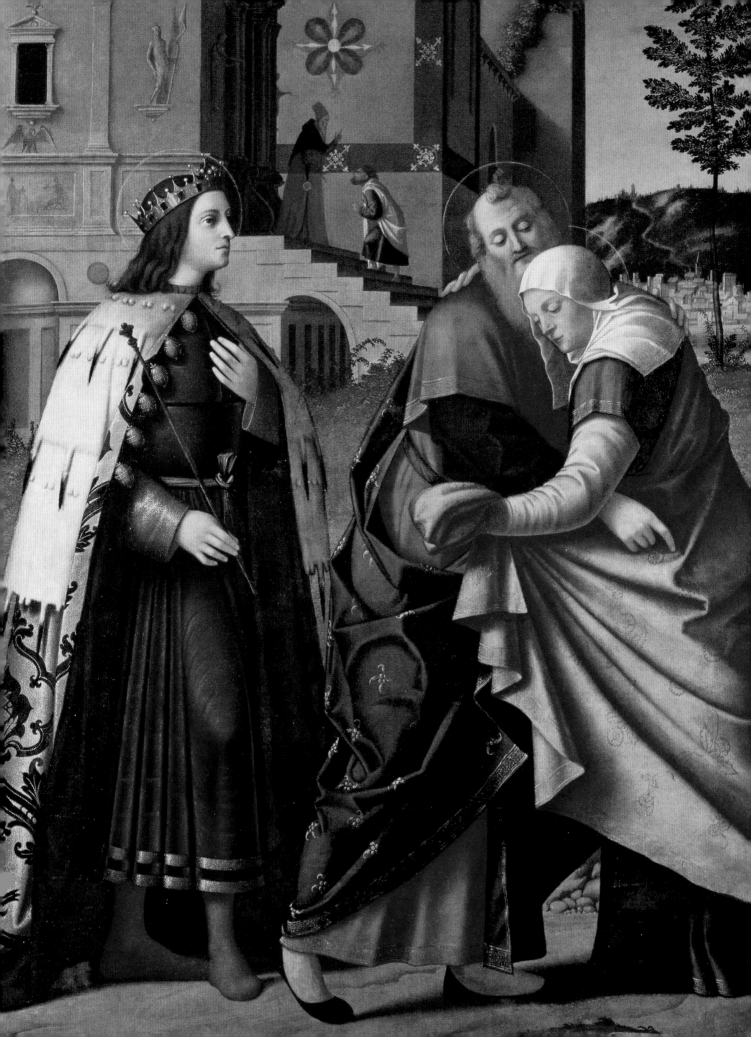

Louis IX's "case" certainly suffered from this "pontifical instability," but also as the result of the stubbornness of diverse powers in Rome who were more stable than the pope, and continually renewed their demands for minute examinations, especially for proof of the miracles, whose importance for canonization was fundamental. Finally Boniface VIII, who was elected in 1294, announced his decision to canonize Louis in 1297. His decision, however, was in part politically motivated: he wanted to establish good relations with Philip IV the Fair, king of France and grandson of the new saint.

The people were becoming impatient. They already venerated King Louis and attributed miraculous powers to his relics (which sometimes complicated the inquests that Rome ordered). The papacy had "beatified" souls who were less well known or whose sanctity was less apparent. Although there were good reasons for Rome's willingness to organize the cult of the saints more effectively, in some quarters it had the opposite effect. But Rome's resolve would not be diminished.

Vittore Carpaccio,
The Meeting of Saint Anne and Joachim at the Golden Gate, with Saints Louis and Ursula (detail),
1515.
Galleria dell'Accademia, Venice.

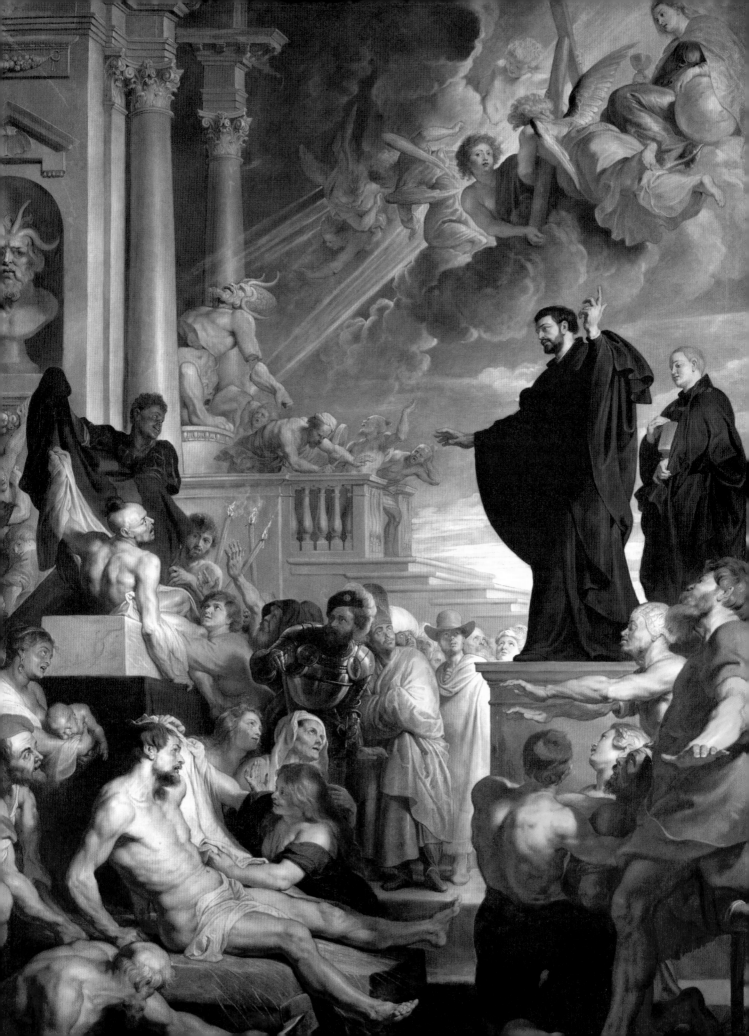

Sainthood on Trial

In the fourteenth century, only six new saints were added to the calendar; this was a sign of the willingness of the pontiffs and their offices to restrict the inflated number of declarations of sainthood. Yet Thomas Aquinas achieved this status without too much difficulty.

This Dominican brother had, however, encountered many obstacles before becoming a monk. Scarcely had he entered the novitiate in Naples, when the members of his noble family banded together to remove him. The Dominicans had a reputation for contesting many aspects of church life and contemporary society, and aristocrats found this troublesome.

Thomas's brothers continued to pursue him as he attempted to head for Paris. He finally came to Cologne, where he studied under another great theologian, Albertus Magnus. He was a Renaissance man before his time (he even attempted to synthesize physics with Aristotelian philosophy and Christian theology). Referred to as a "universal scholar" in his day, Albert would be made a doctor of the Church by Pius XI in 1931, and ten years later was dubbed patron saint of scientists, biologists, and chemists by Pius XII.

Peter Paul Rubens,
The Miracles of Saint Francis Xavier,
c. 1617–18.
Kunsthistorisches Museum, Vienna.

Thomas Aquinas continued his studies as a pupil of Albertus Magnus. He was later a teacher himself in Paris, Rome, and Naples. In Rome he began to write his major work, the *Summa Theologiae*. Its originality lies in Aquinas's synthesis of the traditional thinking of the Church Fathers with the demands of the rationalist philosophy of the period; he successfully allies faith and reason, theology and dialectics, without altering the faith in any way. His philosophy had a broad influence, despite its detractors. His intellectual work went hand in hand with an intense spiritual life. In the late nineteenth century, Pope Leo XIII proclaimed him the patron saint of Catholic teaching. But his canonization, a relatively swift process for a theologian and an exceptional rarity in the fourteenth century, marks a radical evolution in the procedure of recognizing sainthood.

This evolution dates back to the canonization of Stanislaus, bishop of Cracow, who had quarreled with King Boleslaw II, an immoral and cruel monarch, who was excommunicated by the bishop and took his revenge by splitting Stanislaus's head with a sword. Stanislaus was canonized much later in 1254. After that year, however, no other Christian victim of a violent death was canonized until the late fifteenth century: this period marks the end of the identification of martyrdom and sainthood. But especially in the sixteenth century, missionaries, pilgrims, and princes would have benefited if the traditions of earlier centuries had been upheld.

From then on, the popes almost exclusively favored those who embraced an attitude of chastity, poverty, and obedience. Evidently the popes wanted to offer

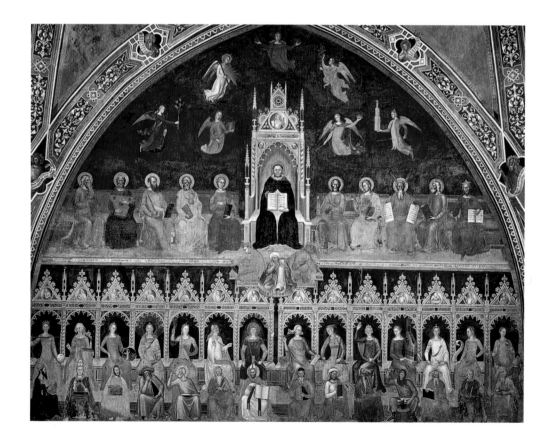

models of faith that were intended to be imitated rather than saints who could be invoked to work miracles or provide protection. Those who did perform miracles, especially women, might be considered guilty of witchcraft. Joan of Arc was condemned as a witch by an ecclesiastical court and turned over to the English who burned her at the stake.

Proof of miracles was certainly still required to confirm one's reputation as a saint. But preachers only spoke of moral and spiritual virtues. Pope Innocent IV, for instance, declared that a virtuous life had to be "continuous and uninterrupted." So the number of laypersons who were canonized fell dramatically. The only man who qualified was a Provençal noble, Elzéar of Sabran, an introspective soul who had visions and, although he was married, remained voluntarily celibate for twenty-five years.

Nonetheless, the people would not abandon the cult of "their" saints who had been accepted in centuries past; their reassuring miracles were handed down from generation to generation. In most cases, the local clergy offered more encouragement than resistance.

A lasting barrier had been erected, and another revolution of the cult, the Reformation that would condemn it, was already fomenting.

It was a time of radical innovation: the discovery of America in 1492, preceded in 1434 by the invention of the printing press; the transition to an economic system that was closer to capitalism; a revolution of thought where the intellectual and cultural world detached itself from religious institutions. But at the same time a genuine need for spirituality arose, an anxious questioning about life after death. In short, ideas and customs were evolving, not only among clerics, intellectuals, and aristocrats. The Lateran Council, which began in 1512 and was closed by Leo X in 1517, a Medici pope who loved learning and luxury, had undoubtedly resolved the Church's problems with its internal organization, but had not taken steps to provide for a renewal of the religion.

In 1517 Martin Luther, a German monk, published ninety-five theses condemning the Vatican's financial practices in paying for the construction of Saint Peter's Cathedral. At the time Luther did not intend to reform the Church, or even less to separate from it, but his relationships with ecclesiastical authorities continued

Andrea da Firenze,
The Triumph of Saint Thomas Aquinas,
c.1365.
Spanish Chapel, Church
of Santa Maria Novella, Florence.

to sour. Luther was excommunicated in 1521. But he had the support of the German people, including Frederick of Saxony. The Reformation had begun, with all its considerable religious, political, and cultural repercussions.

There was also considerable fallout in terms of the cult of the saints. Protestants believe that one must not pray to the saints, since only Christ can act as an intermediary with God the Father, according to the apostle Paul: "For there is one God, and one mediator also between God and men, the man Christ Jesus, who gave himself in ransom for all" (1 Timothy 2:5). So no particular protection should be expected from the saints. Calvin would go even further. Nonetheless, for the Lutheran, Anglican, and Methodist Church, the saints must be considered exemplary models of faith for believers.

A fine polemicist, Luther used arguments that impressed the populace. For instance, people prayed to the apostles, who were so close to Jesus, much less than to Saint Christopher, whose existence was already considered doubtful at the time (and who was eliminated from the calendar of saints in the twentieth century). His name means "bearer of Christ," and is derived from a legend that as a ferryman, one day he had to assist a young child in crossing the river but almost drowned under his weight. The child was supposedly Christ, who himself carries the weight of the world, and so Christopher would have died a martyr. His cult spread rapidly. In the Middle Ages, it was believed that one look at his image was enough to ward off accidents all day long. Christopher became the patron saints of all travelers.

According to Luther's sermons, "the saints are our fellow men and women, the naked, the starving, and those who thirst." Calvin, a Frenchman who was another architect of the Reformation, railed against invoking the saints: "For who has revealed to us that the saints have such long ears that they can hear our words?" But this was not a very serious argument for those who believed in the strength of the spirit.

So it came to be that in Protestant countries, saints' holy days were abolished, their statues were decapitated, and their images and reliquaries were removed from churches that became temples. Nonetheless, Article 21 of the Augsburg Confession—the document that transformed Luther's reform into the Protestant Church in 1530—invites the faithful to preserve "the memory of the saints"

Jusepe de Ribera,
Saint Christopher,
1637.
Museo Nacional del Prado, Madrid.

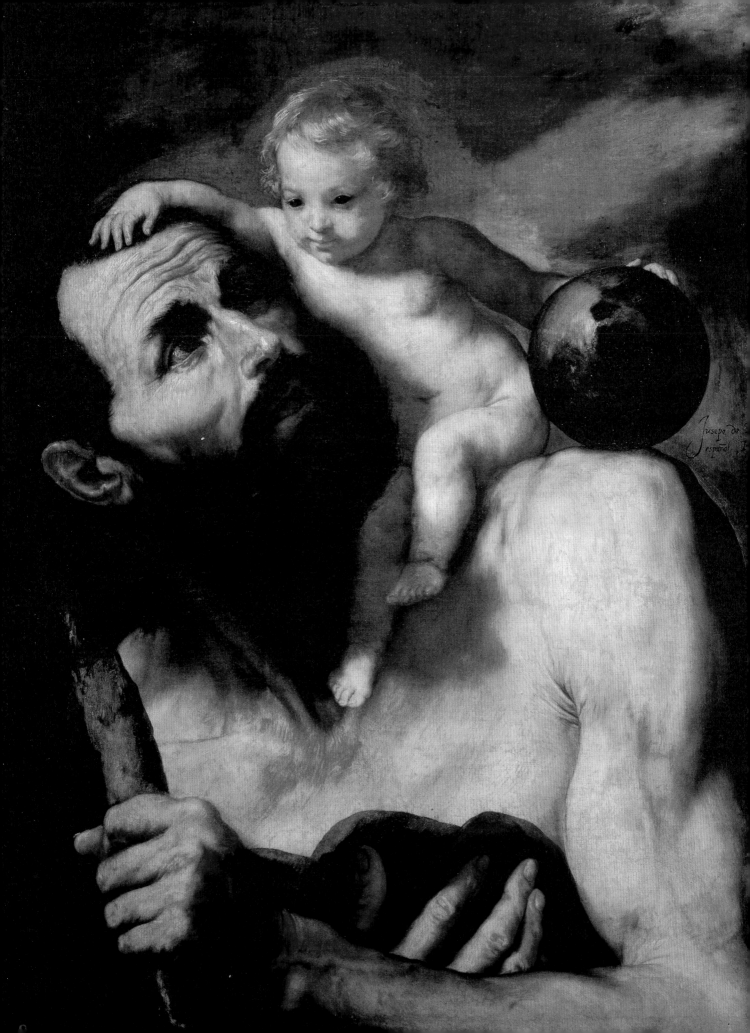

to emulate their faith. Since Luther believed that Christians were saved by their faith alone, they could not reach salvation through merit, acts, or even less by the intercession of a saint's virtues. "After the Holy Scripture, there is certainly no other book that is more useful to Christians than the lives of the saints, especially when they are authentic." The final note of irony is unmistakable.

Rome refrained from canonizing from 1523 onwards and convened the Council of Trent, a conference of Roman Catholic clergy and scholars, in 1545. Extended to 1563, this council was a major event in the history of the Church of Rome. The spirit of reform of this series of popes and bishops was decisive in introducing many steps toward the renovation of the Church. Before it was even convened, the establishment of new religious orders demonstrated the vitality and dynamism that still permeated Catholicism. Saint Angela Merici, born on the shores of Lake Garda, established the first congregation of Christian education for young women, the Ursulines. Ursula herself, who has now been dropped from the Roman calendar, was very popular: the daughter of an English king, she was supposedly massacred with her virgin companions by the king of the Huns on their way to Rome.

In the same period, Saint John of God, a Portuguese man who had had an adventurous youth, converted at age forty-two, repenting so amazingly that he was mistreated as a lunatic. In 1537 he set up a hospital for the sick in the name of the Order of Brothers Hospitallers of Saint John of God, which has borne his name ever since.

Finally, in 1540, Ignatius of Loyola founded the Company of Jesus, whose members, the Jesuits, would play a great role in the renewal of the Catholic Church. Iñigo (his Basque name) was born into a noble family in Loyola, in the Spanish Basque country. A French cannonball that broke his leg at the siege of Pamplona in 1521 changed the course of his life. Surgeons wanted to amputate the leg, but he asked for permission to let the broken pieces mend without interference. This alternative cost him long and sometimes violent pain, accompanied by prayer and long meditations. Once recovered, he wanted to begin a new life of penitence, and so isolated himself in a grotto at Manresa, in the vicinity of the monastery of Monserrat, near Barcelona. There he began to express his reflections and prayers in writing; their definitive version forms his famous *Spiritual Exercises*, intended

for those who want to devote themselves to God. He made a pilgrimage to Jerusalem. The zenith of his mystical life led him to discover his apostolic vocation, but he was convinced that rigorous intellectual study was also indispensable. So he wandered from one Spanish university to another before going to Paris.

He continued to study and pray but did not live a solitary life. In Paris he met Francisco de Jasso from Navarre, who was better known as Francis Xavier, as well as a few other students who were less well known. At Ignatius's instigation, they met in 1534 in the crypt of a small church in Montmartre, built where Saint Denis, the first bishop of Paris, had been martyred. There they made a vow to go to Jerusalem to convert the infidels, as non-Christians were then called, but they wisely added that if this proved impossible, they would put themselves at the pope's disposal for any mission he might assign them. This became one of the rules of their order, which was soon established with the blessing of Pope Paul III (Alessandro Farnese). His pontificate marked the transition to a more militant church.

The Society of Jesus would play the significant role in the Church and the world that it does today; its members were active in all fields: preaching, scientific research, the arts, teaching, missions, and social work, among others. By the time Ignatius died in 1556, the Jesuits—who already numbered nearly one thousand— had established many colleges. Since one of their rules was "to cross the globe and preach the word of God in diverse lands," Francis Xavier had already traveled throughout Asia, an extraordinary journey that led him from Goa to Malaysia, then Indonesia and Japan. This tireless missionary set up small communities and sought out priests or catechists to serve them before taking the ship that would bring him to his next destination.

He had left Japan for China, which was then closed to foreigners, when he fell ill on an island in the harbor of Canton. There he awaited a junk that would take him clandestinely into Chinese territory, accompanied by a young interpreter—which is when he died.

"Although I am very pale," he wrote earlier, "I am more robust than ever. The labor required to educate a nation that loves the truth and seeks its own salvation so sincerely brings one great joy." Ignatius respected the local culture of the countries where he was sowing the seeds of Christianity, especially that of Japan.

At the same time in Europe, the Council of Trent held twenty-five sessions between December 1545 and December 1563, but things began badly. When it opened, only twenty bishops and three superiors of religious orders had convened. There were several other problems: to escape pressure from Emperor Charles V, Pope Paul II had transferred the council to Bologna and also temporarily suspended it. His successor, Julius III, was able to renew it, despite obstacles created by the French king, Henry II, a brilliant monarch and benefactor of the arts who, although a Catholic, did not hesitate to ally himself with the Protestant princes of Germany to expand his territory. At last, after a new interruption, a third session was concluded under the aegis of Pope Pius IV and his nephew, Saint Charles Borromeo, archbishop of Milan, who had become secretary of state at age twenty-one. After much carousing as a youth, Charles became more ascetic, but showed a genius for organization and reining in recalcitrants that proved very useful.

This is not the place to evaluate the considerable significance of this council as the theological response to the Reformation, reorganizing as it did the Catholic Church from top to bottom. However, we should note that it strongly reaffirmed the cult of saints, decreeing that "only an irreligious mentality can deny that the saints, who rejoice in eternal happiness, should be invoked by mankind." The council underscored that any "abuse" of the veneration of relics and holy images must "disappear."

At the same time the pontifical offices were conducting a new purge of the saints' calendar, but the authorities also included a few names. In particular, Anthony of Padua joined the list, a Franciscan who died in Padua in 1231, an excellent orator who converted Toulouse, Brive, and Montpellier, among other cities, and promised eternity in hell to the idle rich. He was invoked for centuries to help find lost objects; children often recited the lines: "Saint Anthony of Padua, you who can find every-thing, please help me find ——" Why was such a power attributed to Anthony? Because one day when the saint's prayer book had disappeared (it was taken by a light-fingered novice), Anthony invoked the Lord and the novice returned his psalter.

Bonifazio Veronese,
Saint Peter and Saint Anthony of Padua,
before 1543.
Galleria dell'Accademia, Venice.

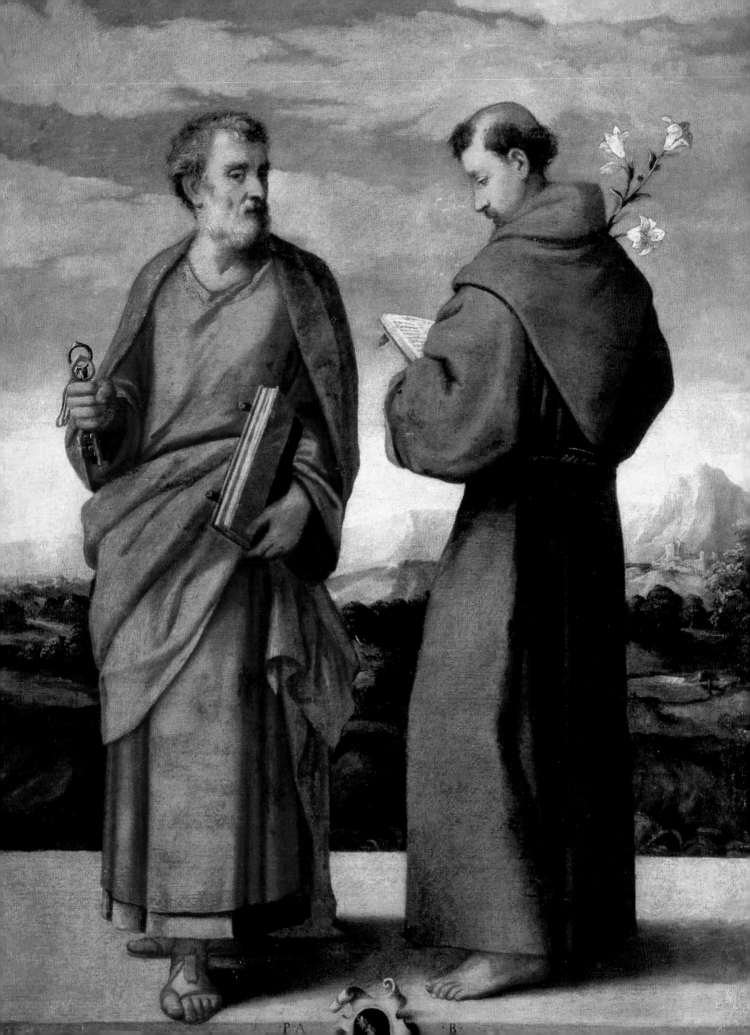

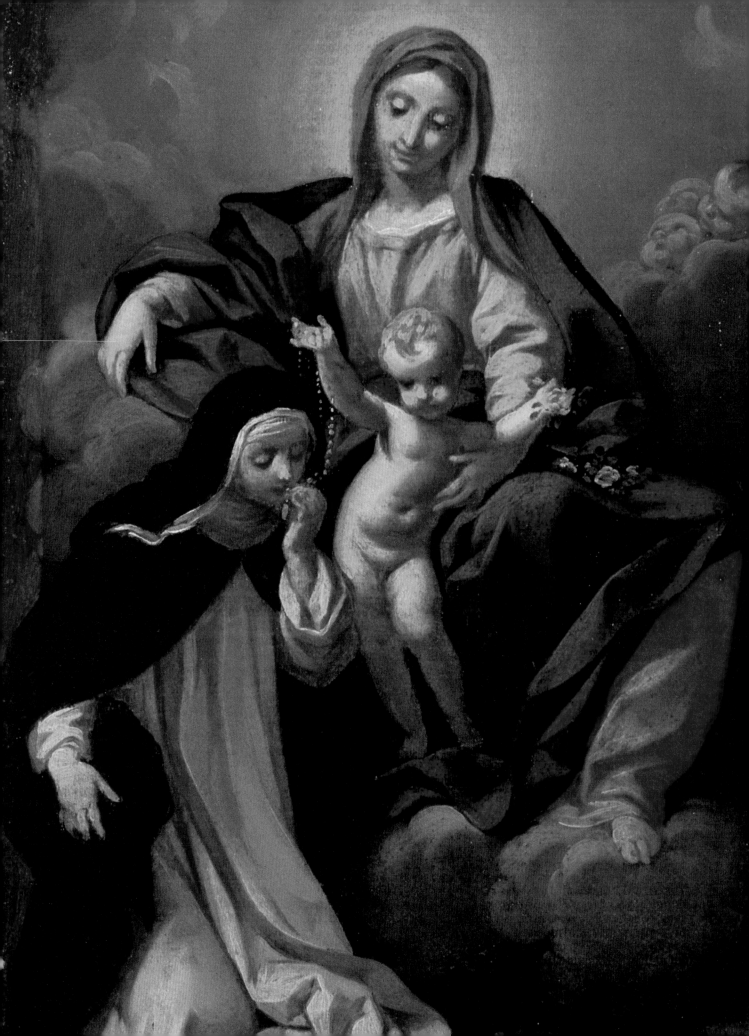

The procedural reform of the process of canonization was obviously not limited to removals and additions to the Roman calendar; it advanced in further stages after the Council of Trent. In 1588, Pope Sixtus V set up the Congregation of Rites, responsible for preparing canonizations and verifying relics. Pope Urban VIII was a Florentine who had left bitter memories among both the Romans (money-hungry, he ceaselessly increased taxes) and the other Europeans involved at the time in the Thirty Years' War (he betrayed all sides in turn); in 1625 and 1634, he became interested in the saints. This absolute sovereign felt that it was necessary to centralize canonizations even more and forbid any public veneration of uncanonized people. The status of a "beatified" person, whose cult was at the time limited to one country or a specific geographic area, was more precisely defined. Urban also forbade the publication of a book on miracles attributed to anyone who had not been solemnly proclaimed beatified or a saint, and so on.

But canonizations still increased in number. There were twenty-five in the seventeenth century. Besides those of Ignatius of Loyola and Francis Xavier, there was Saint Teresa of Avila, who was also called Teresa of Jesus. The daughter of a Castilian burger, she entered the local Carmelite monastery in 1535. Like many others at the time, the rather simple original rule of the order was inconsistently respected: the Carmelites received visitors, sometimes went into the town, and so on. For about twenty years, Teresa of Avila tolerated the laxity. Later, she had a series of mystical experiences: visions, ecstasies, and apparitions. Feeling compelled to respect the rule of the order more seriously, the nun established a reformed convent of strict observance in Avila, but not without difficulty. The nuns' desire to give up worldly possessions was especially characterized by the fact that they were barefoot, which is the origin of the name "The Discalced Carmelites," (from the Latin *discalceare,* "to take off shoes"). Teresa had also persuaded a young monk, the future Saint John of the Cross, to do the same in the monasteries for men. The number of convents of strict observance then began to increase. When Teresa of Avila died, there were sixteen such establishments for women and fourteen for men. Moreover, she left a legacy of several works on spiritual life, especially *The Way of Perfection* and *The Interior Castle,* which describes the soul's path to grace.

Antonio Consetti,
**Madonna with a Crown of Roses
with Saint Rose of Lima** (detail),
1720.
Museo Civico d'Arte, Modena.

For her contribution she was the first woman to receive the title of Doctor of the Church, conferred by Pope Paul VI in September 1970.

Among the newly canonized in the seventeenth century was Rose of Lima, the first woman saint of the New World. As her name indicates, she was born in the capital of Peru (of which she would become the first patron saint). Her given name was Isabel de Oliva, and she belonged to a family of Spanish origin. She was impressed by the life of Catherine of Siena who, after she entered the Dominican order in the fourteenth century, had extraordinary spiritual experiences as she preached reform and intervened in the Church; she had influence with the papacy.

What impressed Rose of Lima the most about Catherine was her mortification and mystical trials. To emulate her, Rose entered a small cell set up in her parents' garden where she remained until her death. Her reputation as a saint is based on the stark contrast between her life and that of the idle Spanish colonial society of the period.

The canonization of such models of ascetic, spiritual, and mystical life, offered to Catholics after the Council of Trent, produced splendid celebrations in Rome. At the same time, sumptuous altars in brilliant colors were erected to the glory of the new saints. The Church commissioned the greatest painters and most talented sculptors to represent them, like Bernini, who fashioned a famous statue of Teresa of Avila. Baroque art, with its lively exuberance, contrasting with the sobriety of many monuments from centuries past, was born in Italy in the seventeenth century. The Catholic Church could only reap its benefits. This spring-like flowering of ecclesiastical buildings contrasted with the rigor and stark sobriety of many Protestant churches.

The Reformation also engendered many changes in the Catholic Church; dogma was strengthened and, in spite of the luxurious lifestyle of the popes—all too often unsaintly and too political—rules and codes were more rigorously enforced, often because the popes wanted to strengthen their power. This is clear when we look at the evolution of the cult of the saints, revealing a certain reserve vis-à-vis canonizations but also bringing to light the exuberant forms of worship of the saints, thanks to the new artistic movement.

Pompeo Batoni,
The Ecstasy of Saint Catherine of Siena (detail),
1743.
Museo Nazionale di Villa Guinigi, Lucca.

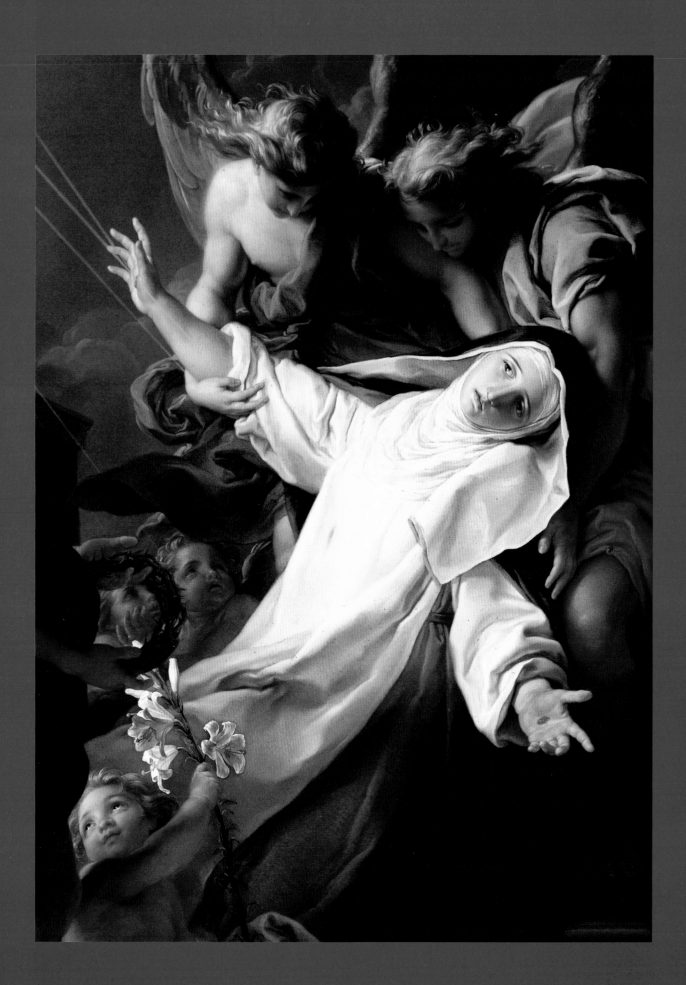

The Cloister
in the Streets

The world became a different place in the eighteenth century, the Age of Enlightenment. Changes were manifold: revolutions in France and elsewhere jeopardized the crown and altar; the new United States of America had developed a Constitution that acknowledged God but also propagated notions of liberty; the discovery of unknown lands with their people and customs reversed some ideas and broadened others; scientific discoveries had begun to alter everyday life radically and inspire thinkers and philosophers with a new faith in reason, so that many people now opposed the Christian faith. The French Revolution even tried to instigate the cult of the goddess Reason. Victor Hugo, who professed to be a believer, wrote in 1875:

> A double inviolability is the most precious possession of a civilised people—the inviolability of territory and the inviolability of conscience; and as the soldier violates the first, so does the priest violate the other.... There is no religion which has not as its aim to seize forcibly the human soul.[1]

1. Victor Hugo, *Deeds and Words*, published in *The World's Greatest Books Vol. X: Lives and Letters*, ebook, (Project Gutenberg, 2004).

Jean-Pierre Gaudin,
Saint Thérèse of Lisieux
Taking Her Vows, September 8, 1890
(detail from the crypt mosaic),
nineteenth century.
Basilica of Saint Thérèse of Lisieux, Lisieux.

All these causes of a new lack of faith are interrelated. A new era began for the Catholic Church and other churches that is still underway, moving in fits and starts, with occasional spirals of faith and fitful dreams of returning to the past. The Church had survived such moments in the past, but rarely with such doubt, suffering, questioning, and searching for the meaning of life.

Of course the cult of the saints also felt this upheaval, but not always in the same way, for each case was different. In Eastern Europe, the Orthodox Churches that had to confront the Muslim conquests often fell back on Russia for support. Until then, canonizations there arose from popular veneration. From 1721 onward, the Holy Synod (a college of bishops) had the power to canonize saints and control the authenticity of relics. Andrei Rublev, the famous monk who painted remarkably beautiful icons, was only canonized by the Orthodox Church (which had been traumatized by modern Russian history) in 1988, during the millennium celebration of "Russia's baptism."

With the spread of skepticism in the West, more doubt was cast on miracles. But the Church, which had fought battles before the French Revolution, increased canonizations in an effort to stimulate popular worship. As a result, a well-known priest from the Landes, Vincent de Paul, was declared a saint. "Monsieur Vincent's" devotion to the poor and charitable acts are well known, but the role he played at secular and religious courts in the nomination of outstanding bishops is less recognized, although their participation was vital to the Counter-Reformation. The life of this humble shepherd, who was received at the Vatican and in royal palaces, is like a fairy tale. But Vincent's story is as true as it is edifying. What is not known is how this peasant became such a talented priest, ordained when he was not even twenty. He took classes at the faculty of theology in Toulouse, fell into the hands of marauding pirates during a voyage in the Mediterranean, apparently spent two years in Tunisia before leaving (or fleeing) to Italy and presenting himself at the Vatican. This was in 1613, after which Vincent de Paul becomes better known. He became tutor to Emmanuel de Gondi's children; their father managed the king's fleets. He then made a vow to devote his life to the poor. He upheld his vow, but he did more than offer everyday assistance. The former shepherd noticed that the peasants on Gondi's estate had absolutely no knowledge of catechism. He then

recalled that God sent Christ "to convert the poor." The salvation of these country people "who were lost in shocking ignorance" had to be ensured.

So Vincent de Paul, who had become an important member of the clergy in Paris, established the Congregation of the Mission, later called the Lazarists, whose aim was to spread the gospel in rural areas. He never stopped caring for the poor, and his work to ensure their welfare was innovative. With Louise de Marillac (a widow who would be canonized) he established the order of the Daughters of Charity, a group of young women of modest background for whom "the street would become the cloister." Today they are called the Sisters of Charity of Saint Vincent de Paul, and they are the largest congregation in the world.

"Monsieur Vincent" went on to pursue many more charitable actions, supporting them with prayer. He would be considered "the great saint of the century." But the French Revolution and the social movements that stirred Europeans in the eighteenth century would lead the Catholic Church to refashion itself and stimulate the cult of the saints. Over four hundred canonizations were celebrated in the nineteenth century, among them many women, and many new congregations were formed. The cult of Mary also increased in many countries, as did her apparitions.

One of the first occurred when Mary appeared to a young peasant woman from Burgundy who had joined the Daughters of Charity in Paris when she was twenty-four. Catherine Labouré was the perfect example of the kind of young missionary woman Monsieur Vincent was looking for. In her first year as a novice on Rue du Bac (which has become an important destination for pilgrims), she had visions of Mary but spoke of them only to her confessor, who almost immediately began a process of canonization. In 1832 the archbishop of Paris had a medallion engraved based on the description of the vision that the young nun gave to her confessor. It bears the inscription: "Oh, Mary, conceived without sin, pray for us who turn to you." Sister Catherine lived out her life in a hospice where she worked in the kitchen, laundry, at the entrance lodge, and in the barnyard; she died at the end of 1876. The medallion was very popular, and miracles and conversions were attributed to Catherine. But the process of canonization initiated by Catherine Labouré's confessor was very slow and ended only in 1947 during the pontificate of Pius XII.

Another nineteenth-century figure, Bernadette Soubirous, the child of a poor family in Lourdes, was helped by Mary's appearances to her from February to July 1858 in a grotto called Massabielle. She was forced to undergo multiple interrogations before submitting to an inquest committee that treated her brusquely for four years. To escape public curiosity, she asked to be admitted to a hospice run by the Hospitable Sisters in Nevers; they also had a house in Lourdes. She was forbidden to speak to anyone about her apparitions and was put to work doing menial tasks, ostensibly to protect her from the sin of pride; she was also humiliated. Bernadette was canonized in 1933 as Marie-Bernard, the name she had chosen when she entered the convent. She is the first saint of whom there is a photograph.

Among the extraordinary women of the period we should also mention Pauline Jaricot from Lyon, the daughter of a silk maker, who in 1822 established the missionary order the Society for the Propagation of the Faith, which spread at the end of the nineteenth century to all countries where the Church had a presence. Although she was very weak, Pauline Jaricot went to Rome to ask the pope to canonize Philomena, a third-century martyr. The martyr was eventually canonized but, for obscure reasons, Pauline Jaricot, whose work was considerable throughout a life of poverty and prayer, was neither beatified nor canonized. Pope John XXIII, however, did declare that she was "venerable."

Fortunately, Thérèse de l'Enfant Jésus (who was also called Thérèse de Lisieux, since her family had moved to that town) fared better. Her mother died shortly after the move to Lisieux, when she was four, so she was raised by her two older sisters. One sister joined the Carmelites when Thérèse was nine and was soon followed by the other. When she was fourteen, Thérèse told her father that she also wanted to become a Carmelite. But this was easier said than done at that age. She held firm and overcame every impediment, and after many prayers succeeded in retreating behind the grille of the cloister when she was fifteen. There she had more physical and spiritual trials (her health was delicate and she died of tuberculosis at age twenty-four), including temptations to disbelieve, "nights of faith," difficulty in praying. Her reputation as a saint quickly spread throughout the world. But it was sometimes distorted, only because she was young, simple, and in poor health.

Anonymous,
Portrait of Bernadette Soubirous,
nineteenth century.
Musée-Trésor des sanctuaires
de Notre-Dame de Lourdes.

BERNADETTE

✦

LOVRDES

✦1858✦

Because she had chosen "the path of childhood" to approach God, her memory is surrounded by an overly sentimentalized religiosity. However, Thérèse was a strong woman who, as she herself put it, simply did not want to become only "half a saint."

"You do not know who I really am," she wrote to a young seminarian shortly before her death. She kept abreast of world events. One episode in her life (which is now well known) bears this out: she had avidly followed the brief trial of Henry Pranzini, who had murdered three women on a boulevard in Paris. She prayed constantly that he would repent. When he mounted the gallows on August 31, 1887, Pranzini told the chaplain that he wanted to kiss the crucifix. Then Thérèse dared to write the words, "He is my third child," because she wanted "to sit at the sinners' table." It made perfect sense that the Church proclaimed her "the patron saint of missions." She was beatified in 1923 and rapidly canonized by Pius XI in 1925, because her cult has spread so widely; Christians had made her a saint before the Church. Then, in 1997, in recognition of the importance of her teaching, John Paul II proclaimed her a Doctor of the Faith, a title attributed to only thirty-three saints, of whom three are women. In 1944, Pius XII declared her the "patron saint of France."

She shares the title with Saint Joan of Arc, a national heroine only canonized five centuries after her death, perhaps because the history of the peasant girl from Lorraine was so extraordinary that many legends and controversies sprang up around it. Saint Joan's story begins in the mid-fifteenth century during the Hundred Years' War. France was at war with England (allied with the duke of Burgundy), who occupied most of the country. When she was sixteen, Joan revealed that for the past three years she had heard the voices of Saint Catherine and Saint Margaret, as well as Saint Michael, who all encouraged her to take part in liberating her country. After confronting many barriers, the following year she was able to meet the young king, Charles VII, who had taken refuge at Chinon, and she persuaded him to give her a small army. The young woman, who lacked any military education or training, succeeded in gaining her troops' respect. She led them to liberate Orléans and the Loire Valley. With her men she triumphantly led the young king across the occupied country to his coronation in Reims.

Jean Auguste Dominique Ingres,
Joan of Arc at the Coronation of Charles VII,
1854.
Musée du Louvre, Paris.

But misfortune soon struck. She was wounded during the siege of Paris, which she did not succeed in liberating. In May 1230, when she was only eighteen, she was taken prisoner by the Burgundians, who sold her to the English. They craftily tried her in an ecclesiastical court on charges of witchcraft. During the trial proceedings, the illiterate woman displayed courage, but also an intelligent faith that bore testimony to the strong religious grounding she had received from her mother and village priest. Declared a heretic, she was turned over to the English, who burned her at the stake in Rouen. She was only nineteen; the king had done nothing to save her. Her amazing life has inspired filmmakers, painters, composers, and writers such as Schiller, Bernard Shaw, Voltaire, Péguy, and Malraux.

Edith Stein's life is more complex but also ends in tragedy. The daughter of a German lumber merchant, she was born on Yom Kippur, the Jewish holiday that is also called the "Day of Atonement," in 1891. Her devout mother was deeply touched by this coincidence. When she was in high school, young Edith turned away from religion when she discovered philosophy, and she joined the most radical faction of a feminist movement. Then she began a brilliant university career that ranged from studying Indo-European languages to the psychology of history. At the same time, she taught penmanship to ordinary workers. Edith became an atheist. When war broke out in 1914, she took nursing courses and worked in a military hospital. A life of so many commitments and such dedication wore her out, but she also advanced her study of philosophy and met Christians through her research groups. After the war ended, she took up the feminist cause again and became a pacifist. She had already started down the long path that would lead to her conversion. While helping the widow of a friend who had been killed in the war, Edith was impressed by the woman's strength. A recent convert, the woman was strengthened by meditating on the crucifix. Above all, after reading the autobiography of Teresa of Avila, Edith Stein decided to become a Catholic. She was baptized in 1922, to her mother's great sorrow, and longed for a contemplative life, but she renounced it at the advice of her spiritual director.

She devoted herself to teaching at a Dominican nuns' school and lecturing. Since Jews were no longer allowed to teach after Hitler came to power in 1933, Stein realized her greatest wish and entered a Discalced Carmelite monastery in

Anonymous,
Edith Stein as Carmelite Nun,
c. 1935.
Location unknown.

Cologne where, like Teresa of Avila, she was still concerned with the outside world. In a letter to the pope, she asked him to condemn Nazism, which might have inspired the encyclical *Mit brennender Sorge* (With Burning Concern), read from the pulpits of all German Catholic churches on Palm Sunday. To avoid persecution, she was transferred to a convent in Holland but was arrested by the German army and murdered in Auschwitz. Edith Stein was beatified in Cologne on May 1, 1987, by John Paul II, who canonized her at the Vatican on October 11, 1998.

Mother Teresa of Calcutta, an Albanian who became an Indian, was cut of similar cloth. But the course of her life was completely different, since she entered an Irish missionary congregation at eighteen that sent her to India and, more precisely, to Calcutta as director of studies at a school for children mainly from the upper castes. But she was not satisfied and remained obsessed with the poverty of the Indian people. In 1948 she was finally given permission to devote herself to the "untouchables" of the community, beginning with the worst outcasts, the lepers and cancer victims. While on a train traveling to a retreat for her community, she received what she described as "the call within a call":

> "The message was quite clear. I was to leave the convent and help the poor while living among them. It was an order. I knew where I belonged."

This was of course true, but there were, once again, many obstacles. She began by giving classes and distributing bars of soap to children in the streets. She begged the pharmacies for medicine. Soon she was joined by a former pupil, then a second, followed by another, and they soon numbered ten. With them she established the congregation of the Daughters of Charity and adopted the sari as their habit. She set up a home for the elderly, a dispensary, and an orphanage.

Mother Teresa was constantly called to places throughout the world from Ethiopia to the USA, and from Bangladesh to Venezuela; she once said, "As to my calling, I belong to the world." She also confessed to having experienced "black holes" in her spiritual life during which she did not feel the presence of God, but despite her crises of faith, she persevered in her mission to help the poorest of the poor.

Mother Teresa died in Calcutta in 1997 and was beatified by Pope John Paul II in 2003. But since the death of the pope, who had pending files on local "causes for sainthood" dusted off for review (especially before visiting another country), canonizations have become much more infrequent.

Since the early twentieth century, the procedures governing canonization have become much stricter. In 1930 Pius XI created a "historical divison" of the Sacred Congregation for Rites (founded by Sixtus V in 1588), responsible for studying the saints' "causes." In 1948 Pius XII created a "medical college" of experts who were consulted on the miracles and extraordinary manifestations, such as stigmata.

After Vatican II, this congregation was replaced by the Congregation for the Causes of Saints, which simplified the procedure in principle. The calendar of saints was reformed to a list of one hundred eighty names in the Catholic Church, while others could be celebrated or venerated in their own country or on their continent of origin. The new code of canon law increased the conditions and procedures of inquiry. Then a group of cardinals, who were members of the new congregation, presided over by the Pope, decided if the case should advance to beatification. One of the necessary conditions was that at least one miracle should have occurred through the candidate's intercession, unless he or she died a martyr. After beatification, the case would remain dormant unless "supplementary divine signs" had been seen (which would necessitate new inquests).

In short, despite the "interlude" that the Church experienced during John Paul II's papacy, canonizations and beatifications have become increasingly rare. Nonetheless, they have undergone a marked evolution: among the new saints and the beatified who are proposed for veneration by the faithful, there are individuals who were not in high social or political positions. In other times, they would have remained anonymous, the so-called "little people." But this is a misnomer, since they were among the great. Jean-Baptiste-Marie Vianney, better known as the priest of Ars, was one of them.

When he was nominated in 1817, after the French Revolution and the Napoleonic Wars, Ars was a forgotten village in the Ain, a region that had been almost completely divested of Christianity. The son of a poor peasant family, Jean-Marie wanted

to be a priest at an early age, but was not a gifted student and had to wait and struggle hard until he was thirty before joining the priesthood. The authorities in the diocese, who had originally sent him to seminary, did not have high hopes for him. But Jean-Marie believed in himself, although he suffered from the bad treatment he had received from some others in the seminary, as well as from the indifference of his parishioners, and contempt from the well-to-do. Nonetheless, he continued to pray and lead an ascetic life, teaching those who came to him for advice and advising them with common sense. When he was ordained, he was given a surprising caveat that was only removed after three years: he was not allowed to hear confession. He obeyed stalwartly, but he must have been distressed by that, too.

The rest of his almost legendary life is somewhat mysterious. How did the reputation of this poor priest with no connections begin to spread from this small village? It is not clear exactly, but it must stem from his simple grace and gift for welcoming and listening to others. He proved to be a remarkable confessor, often spending from sixteen to eighteen hours a day listening to penitents who came from near and far, sometimes from other countries. Many who sought him out might have felt superior to their own priest but not to him. He never ate or slept enough and is believed to have had supernatural powers.

Jean-Marie shunned fame and yearned for the contemplative life of the monastery at La Trappe. But his parishioners would have nothing of it, and the same authorities who had belittled him made him a canon. Emperor Napoleon III wanted to decorate him with the Legion of Honor, but he refused. Rome waited longer but canonized Saint Jean-Marie Vianney in 1925.

The Italian Giovanni Bosco, son of peasants in the area around Turin, was also neglected at first. He had to work to earn a living as a student. After his ordination, he decided to devote himself to street children in poor neighborhoods, after seeing a church sacristan give a good thrashing to a bad boy. Don Bosco opened a home for these boys, but his catechism lessons drew so many pupils that he had to move his oratory to a shed and then to disused chapels. His activity was not limited to lessons or opening new schools. He set up youth clubs, and when his activities became more diversified, he hired priests as teachers, with whom he established

the Society of Saint Francis de Sales that still bears his name. The Salesians still carry out his work. With the help of Mary Mazzarello he founded a congregation of nuns, the Daughters of Mary, Help of Christians, to do for girls what the Salesians were doing for boys. Both groups taught, provided professional training, did pedagogical research, and strove to strengthen the faith in working-class neighborhoods. His model was followed throughout Europe. In 1958 Pius XII proclaimed Giovanni Bosco the patron of apprentices.

In similar vein was Marcel Callot, a Breton, born just after the First World War ended. When he was twelve, he left school—like most working-class children at the time—to learn a trade on the job, typography, and soon joined the Young Christian Workers organization. His convictions were the butt of much sarcasm. Under orders from the Third Reich during the occupation of France in 1943, the Vichy government created the Mandatory Work Service, which sent young Frenchmen to work in German factories. This was no easy choice for Marcel: he could refuse, go into hiding, and join the Resistance, or obey as a militant Christian and follow his comrades, carrying out the goal of the Catholic Action group (an apostolic mission of similar-minded individuals).

He chose to go to Germany, where he worked hard in factories and was poorly housed. When he brought together a group of other French workers, the Gestapo became suspicious and put him in prison. Soon thereafter he was transferred to the concentration camp at Mauthausen, known as *Knochenmühle*—the "bone grinder"—among the German High Command. Prisoners were forced to work in an underground factory. There, too, he assembled other detainees in prayer and comforted the weakest. When he became too sick to work, he was put in the so-called infirmary where patients were piled on the ground. He died there of exhaustion. John Paul II beatified the martyr in 1987.

And finally there is Maximilian Kolbe, a Polish Franciscan priest, who returned to Poland, where he wrote for the Catholic press, after a stay in Japan. On September 1, 1939, German troops crossed the Western border, followed by the Red Army at the Eastern border. The occupation was brutal. The Gestapo arrested Father Kolbe, then released him before arresting him again and sending him to Auschwitz, the

camp of no return. One of Kolbe's coprisoners tried to do the impossible and made an unsuccessful attempt to escape. Although he was a married man and a father, he was sentenced to be executed. Maximilian Kolbe offered to take his place, a seemingly pointless gesture, since the chances of survival at Auschwitz were practically nil. But it was a symbolic victory over the universe of the camps, designed to kill the human spirit and personal dignity as well as the physical body. It was a gesture of spiritual resistance in which the soul triumphed, as it did for so many martyrs.

Throughout the world, individuals continue to sacrifice their lives in the name of their faith so that others might live. Yet many of these altruists remain unrecognized as the Church, out of cautiousness, strengthens the regulations for sanctity in order to distinguish only a select few.

In April 1989, Cardinal Ratzinger, the second most important person in the Vatican and the future Pope Benedict XVI, gave a speech in the small town of Seregno near Milan, where he referred to the problematics of canonization. He suggested that sainthood did not always hold much meaning for masses of believers. This comment sparked heated debates, especially in the Italian and American media and press. Some time later, Ratzinger qualified his remark by recognizing the existence in the world of "many more saints than those who can be canonized."[2]

Most fortunately for those who go unrecognized, the Catholic Church has created All Saints' Day.

2. In the monthly magazine *30 Days*, May 1989.

Anonymous,
Mother Teresa,
1979.
Bonn (location unknown).

INDEX OF PROPER NAMES

Page numbers in bold refer to illustrations.

All illustrations are from the agency akg-images
(www.akg-images.fr)

akg·images
Paris Berlin London

PHOTOGRAPHIC CREDITS:
akg-images / Bildarchiv Steffens: p. 95
akg-images: pp. 39, 42, 43, 53, 59, 70, 98, 130, and 150
akg-images / André Held: p. 79
akg-images / British Library: p. 62
akg-images / Cameraphoto: pp. 4–5, 6, 12, 27, 32–33,
35, 55, 80, 82, 83, 117, 127, and 137
akg-images / De Agostini Picture Library: pp. 77, 142,
and 147
akg-images / Electa: p. 138
akg-images / Erich Lessing: pp. 19, 26, 30, 38, 44, 64–65,
71, 88, 96, 119, 120, 123, 128, and 133
akg-images / François Guénet: p. 148
akg-images / Joseph Martin: pp. 36, 50–51, and 111
akg-images / MPortfolio / Electa: pp. 10–11, 21, and 141
akg-images / Orsi Battaglini: p. 47
akg-images / Pirozzi: pp. 16 and 56
akg-images / Rabatti—Domingie: pp. 9, 22–23, 41, 60,
91, 92, 108, and 121
akg-images / RIA Novosti: p. 103
akg-images / Tristan Lafranchis: p. 112
akg-images / ullstein bild: pp. 104 and 157
Philippe Maillard / akg-images: pp. 7, 8, and 73
R. & S. Michaud / akg-images: p. 29
The National Gallery, London / akg-images: p. 107
Yvan Travert / akg-images: p.68

Translated from the French by Kenneth Berri
Design: Montag (Juliane Cordes and Corinne Dury)
Copyediting: Penelope Isaac
Proofreading: Chrisoula Petridis
Color Separation: Reproscan
Printed in Slovenia by Gorenjski

Simultaneously published in French as Les Saints
© Flammarion, S.A., Paris, 2012

English-language edition
© Flammarion, S.A., Paris, 2012

87, quai Panhard et Levassor
75647 Paris Cedex 13

editions.flammarion.com

12 13 14 3 2 1

ISBN: 978-2-08-020134-8

Dépôt légal: 10/2012

DETAILS

Pages 4–5
Giotto di Bondone,
Joachim's Dream (detail),
c. 1303–05.
Scrovegni Chapel, Padua.

Page 6
Giovanni Battista Cima da Conegliano,
Saint Lucy (detail),
c. 1486–88.
Church of San Bartolomeo, Olera.

Pages 7 and 8
Icon,
Saint Pachomius (details),
1779.
Private collection, Paris.

Page 9
Benvenuto di Giovanni,
**Saint Peter Holding
the Keys to Heaven** (detail
from *The Ascension of Christ*),
1491.
Cloister of Sant'Eugenio, Siena.

Pages 10–11
Pompeo Batoni,
**The Ecstasy of Saint Catherine
of Siena** (detail),
1743.
Museo Nazionale di Villa Guinigi, Lucca.

Page 12
Giovanni Battista Cima da Conegliano,
**Saint Catherine
of Alexandria** (detail),
c. 1486–88.
Church of San Bartolomeo, Olera.